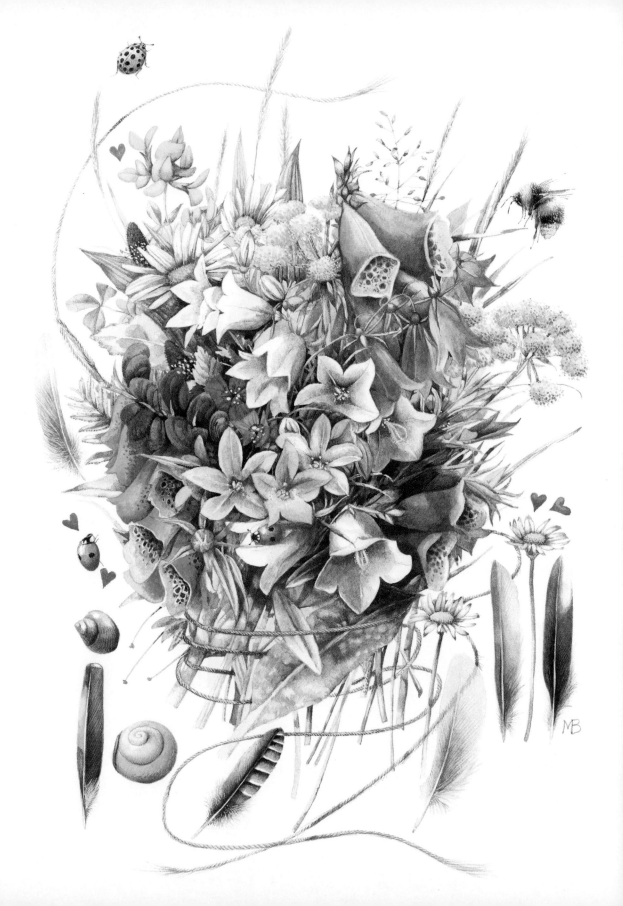

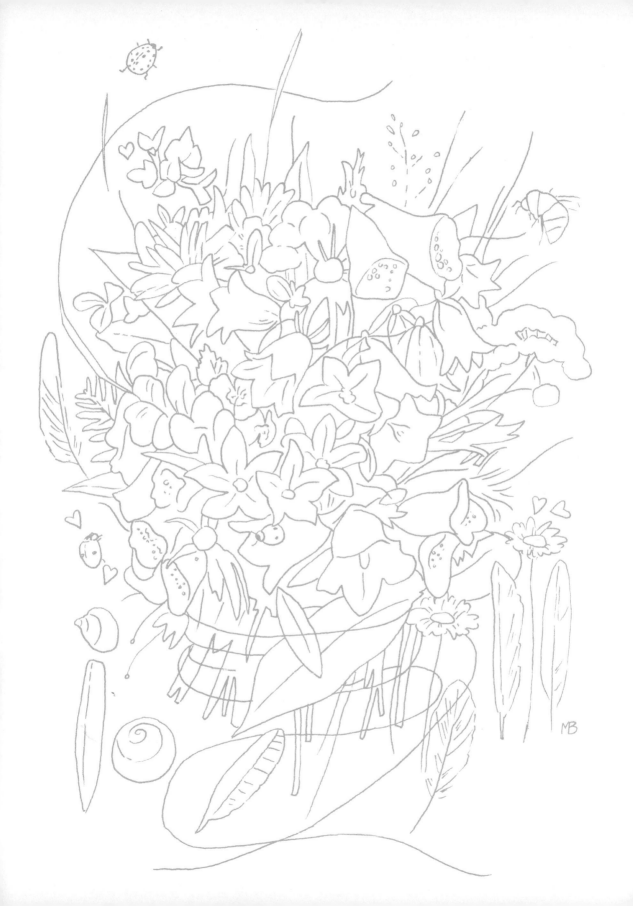

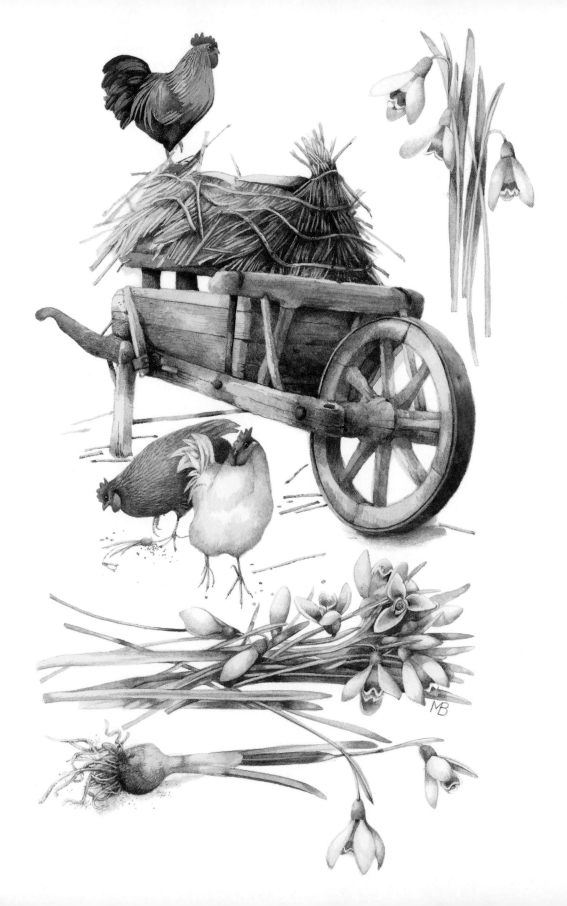

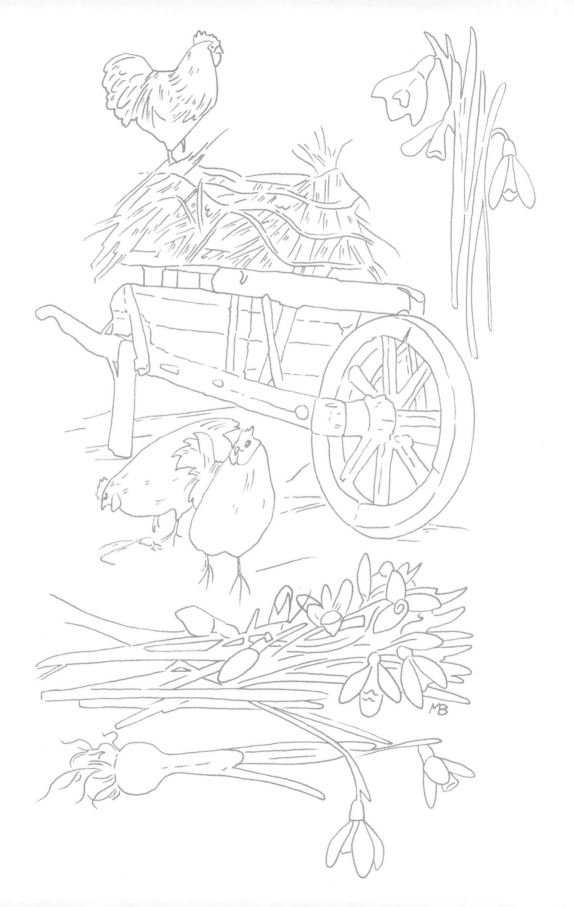

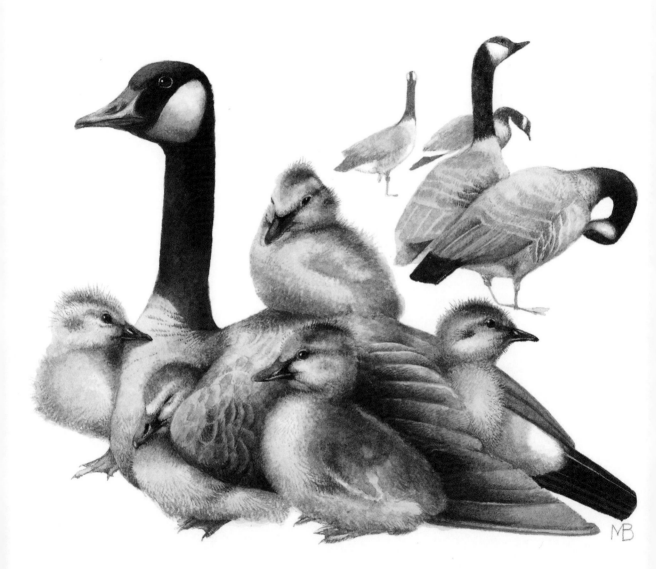

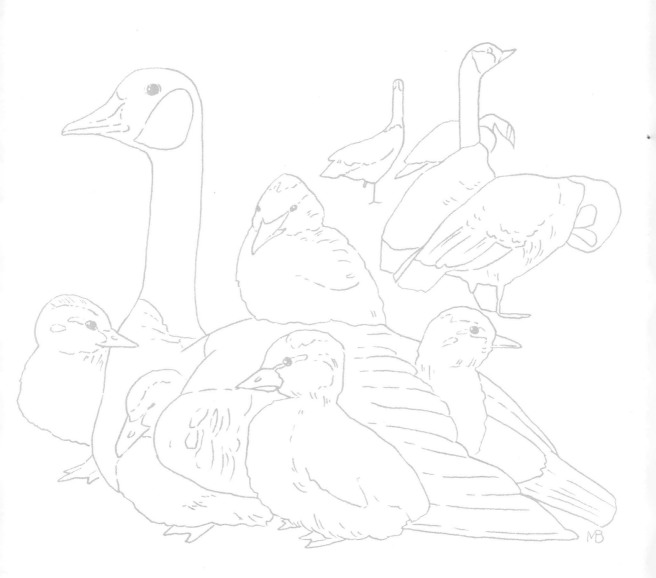

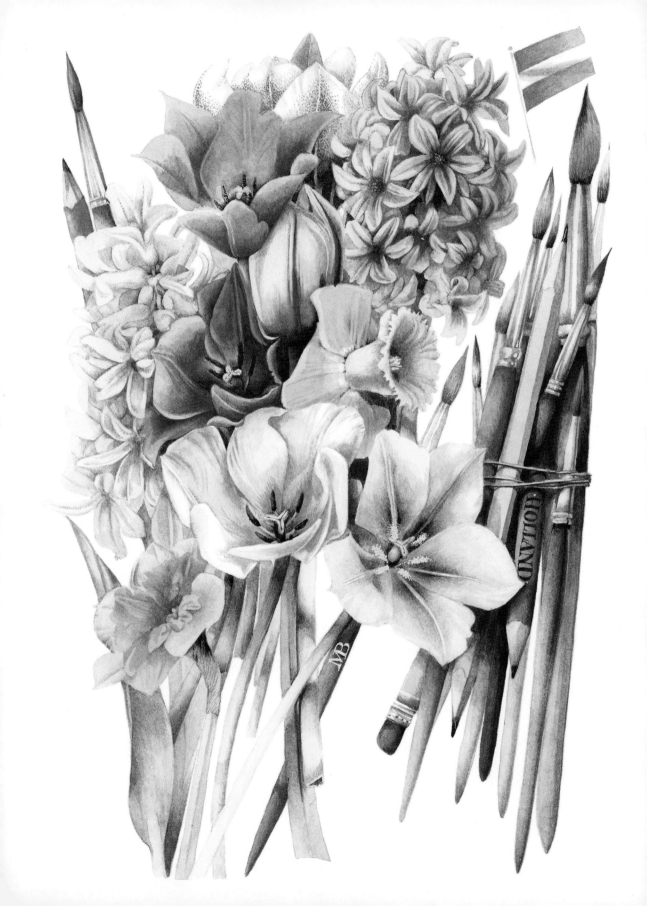

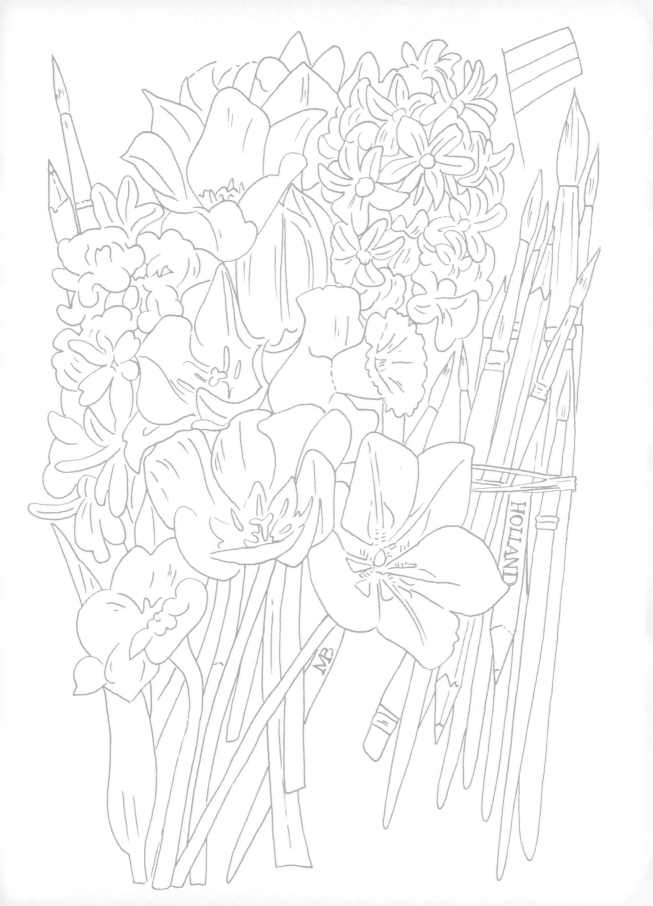

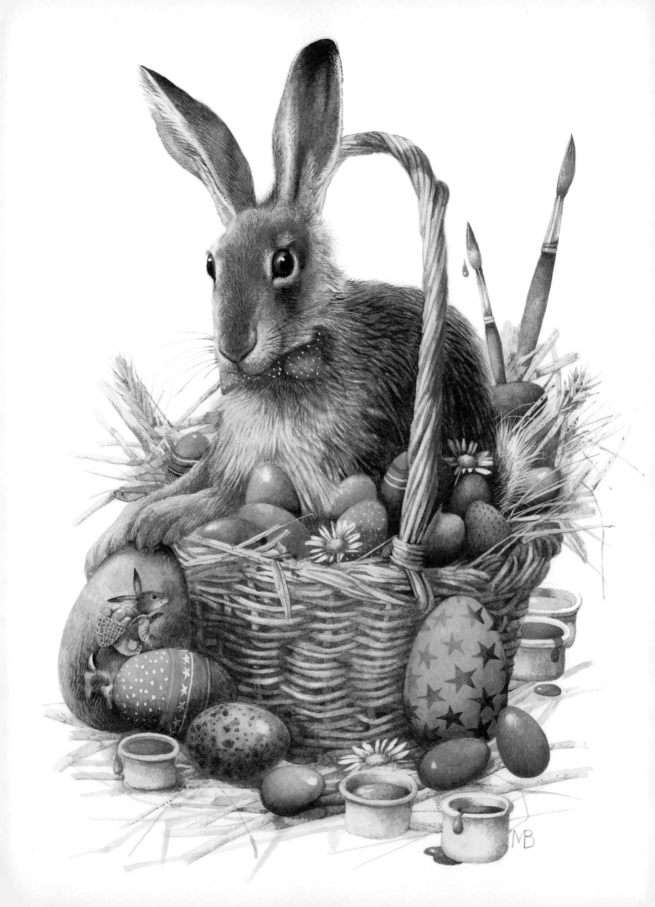

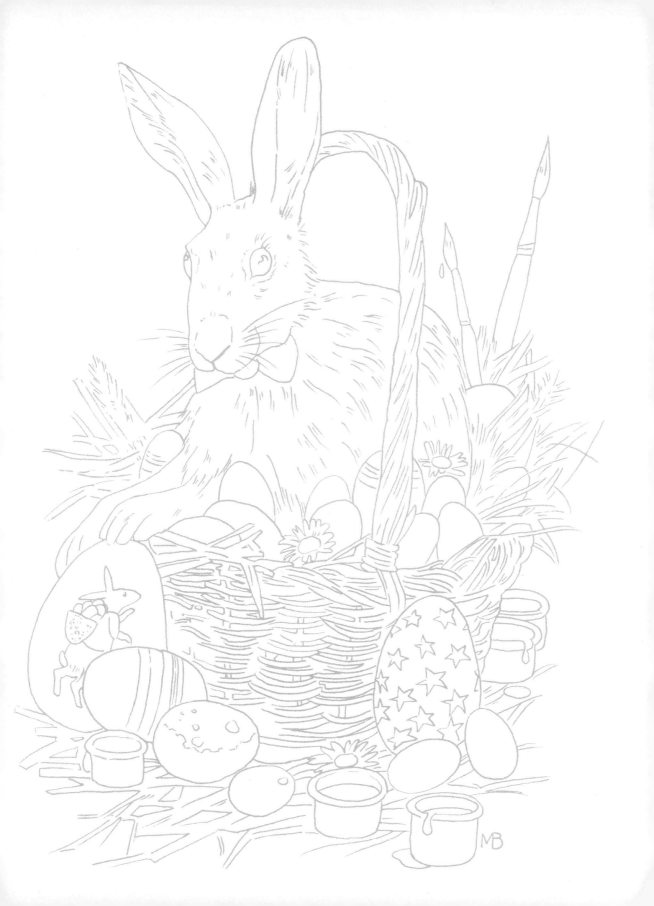

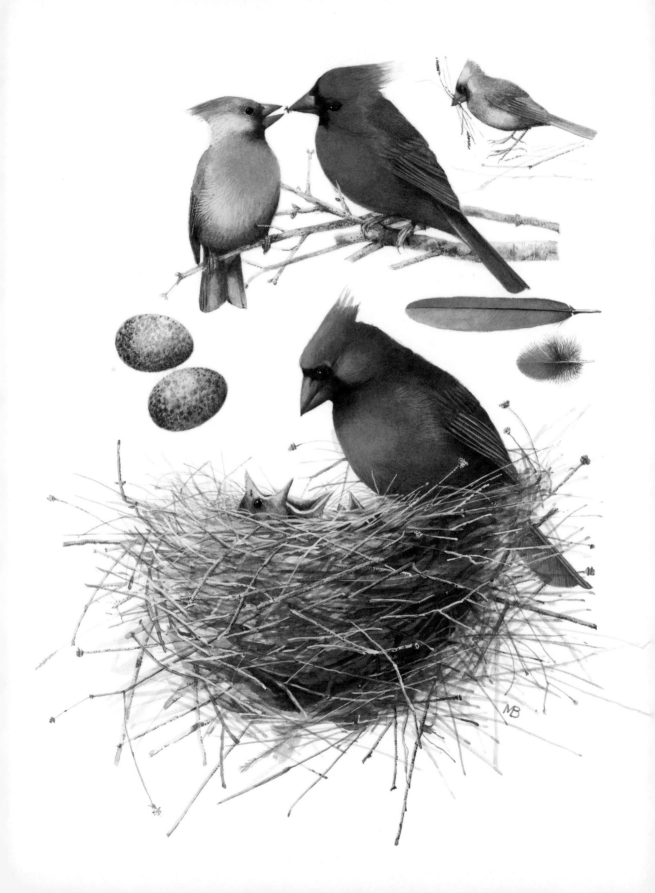

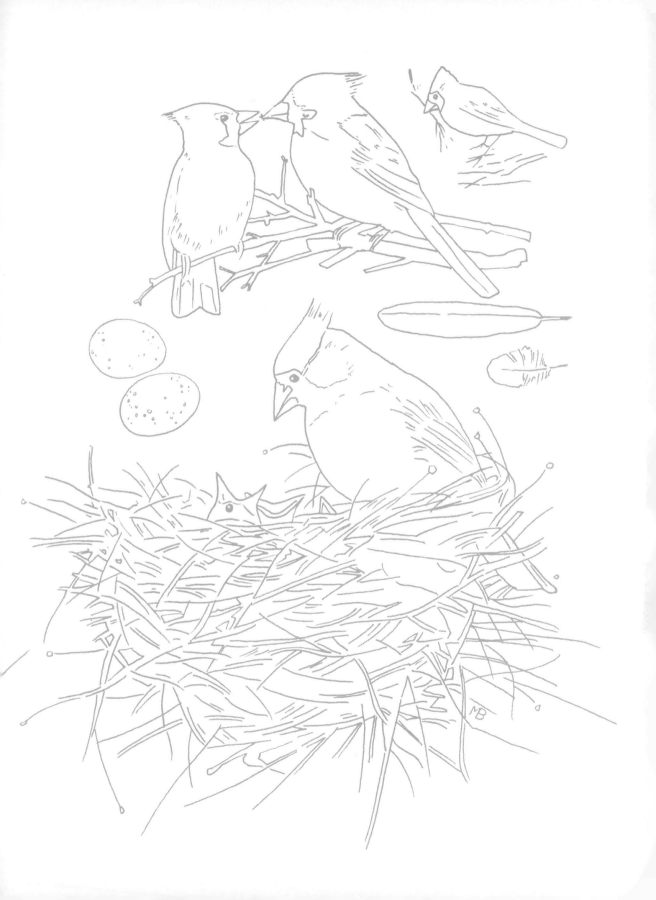

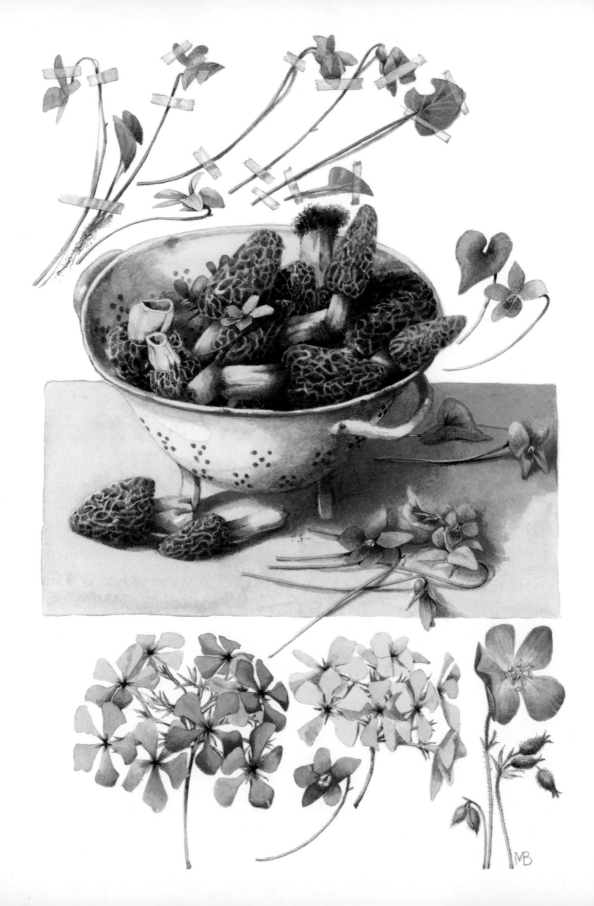

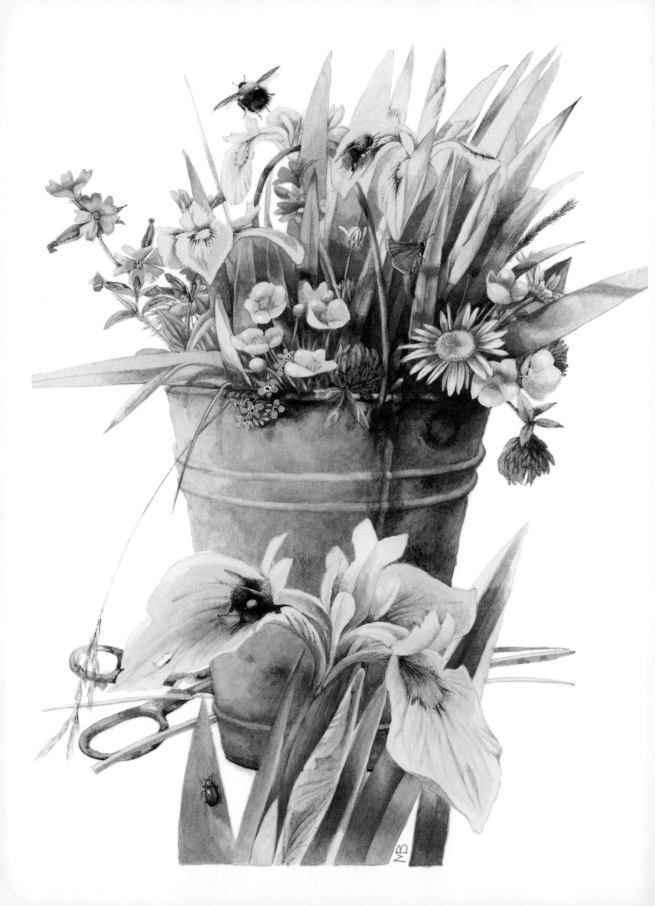

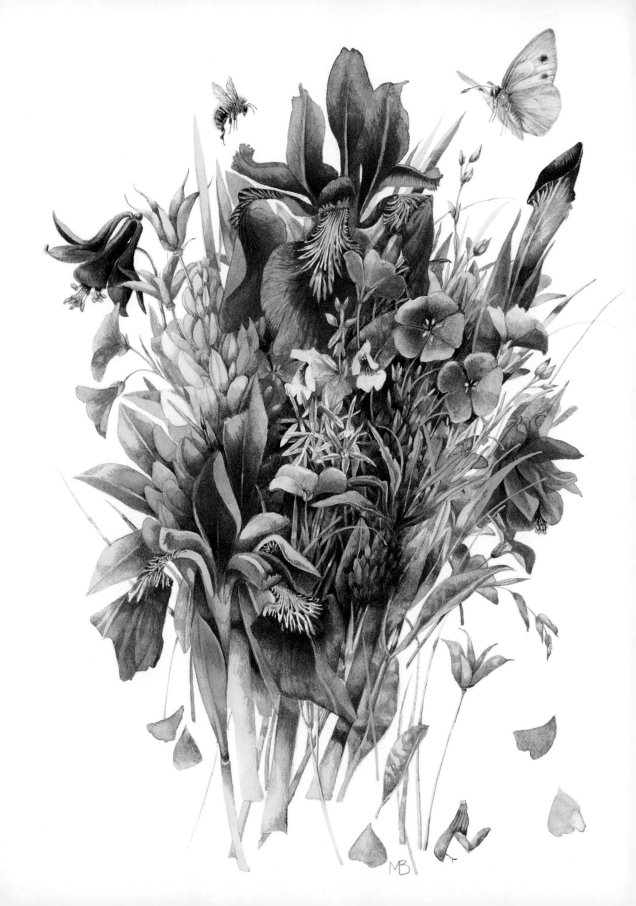

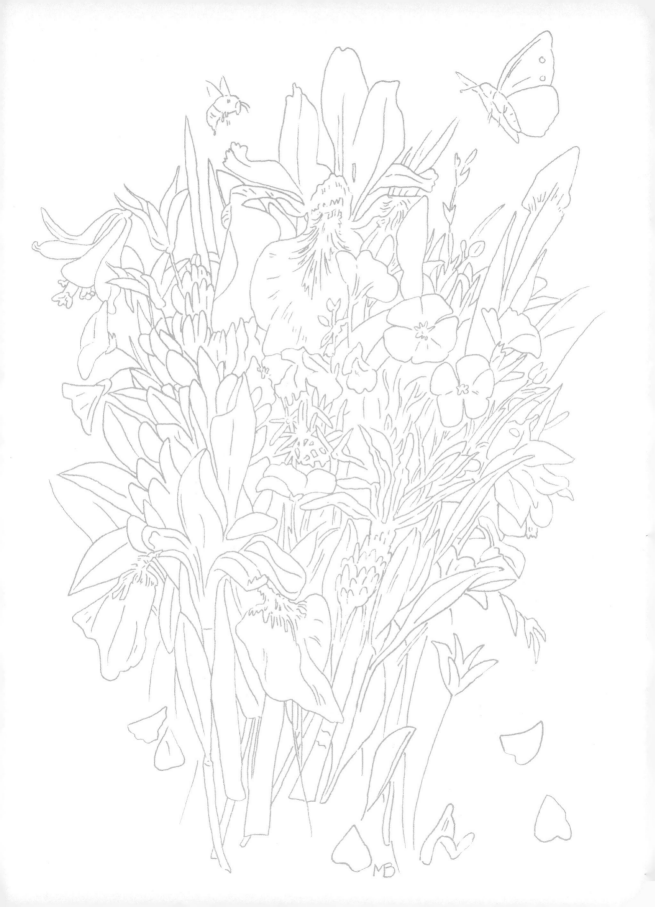

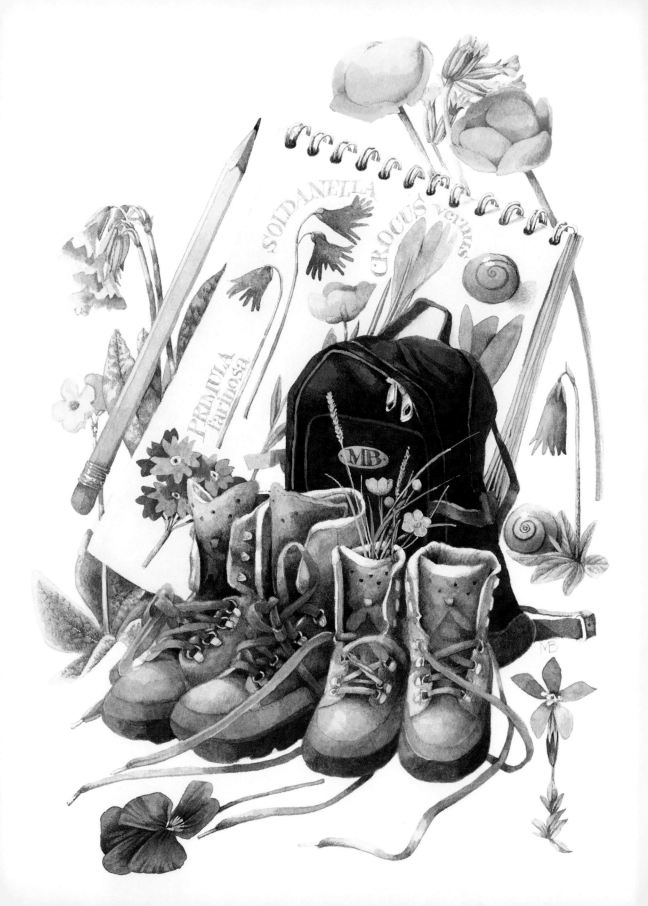

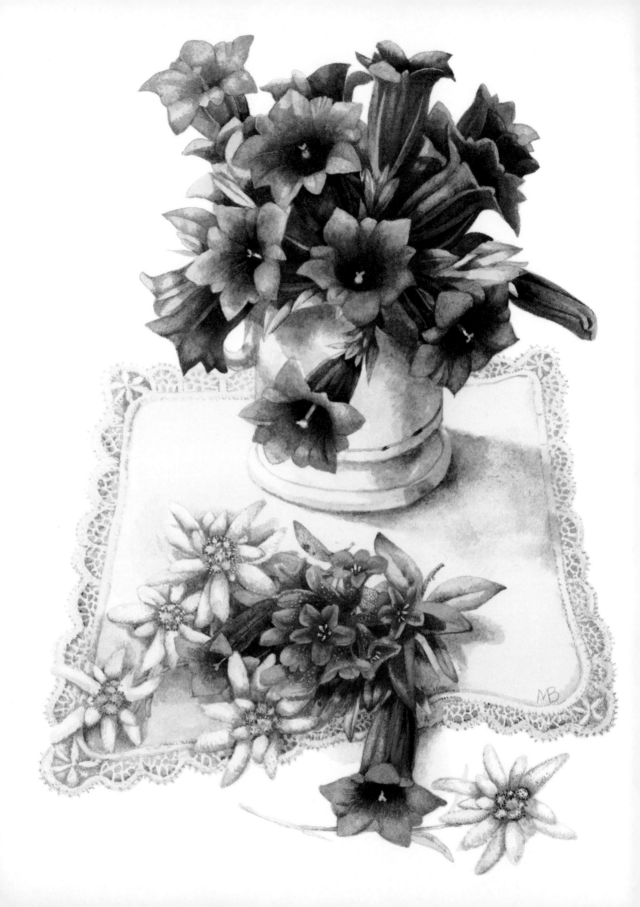

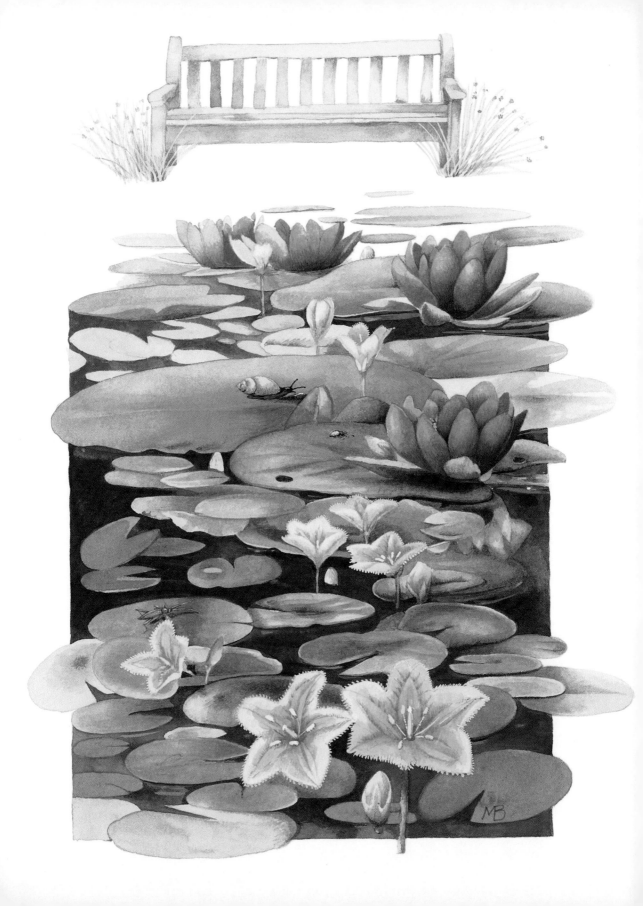

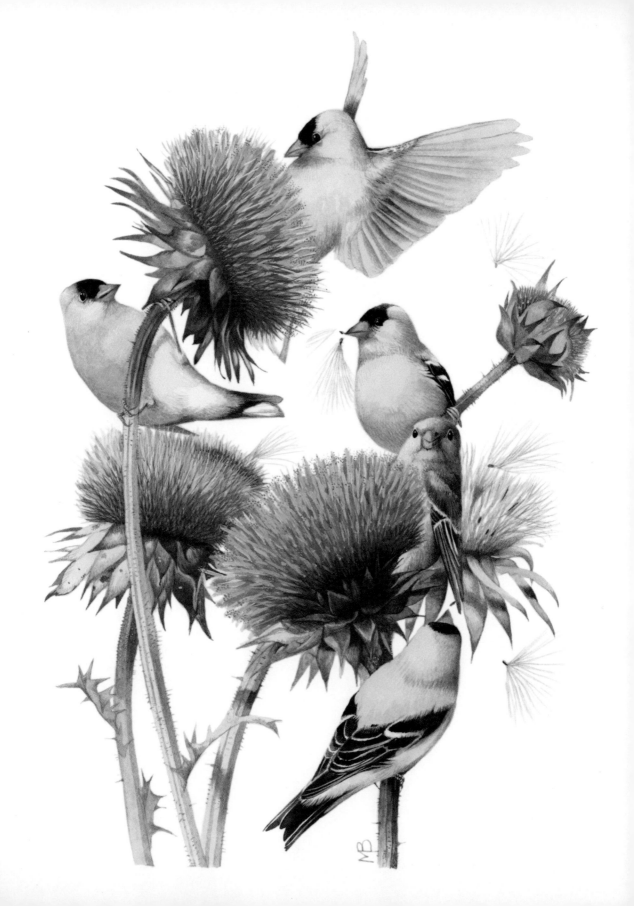

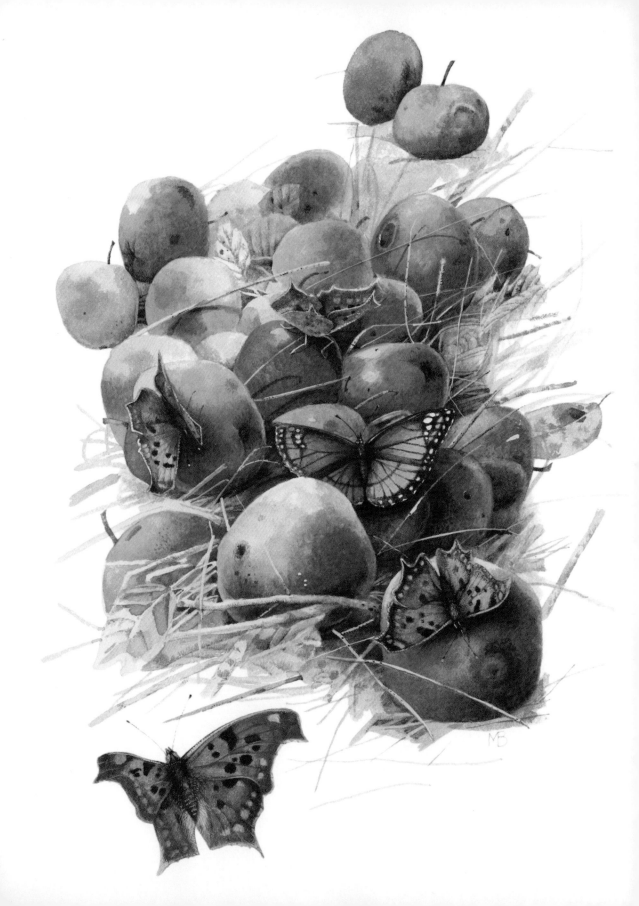

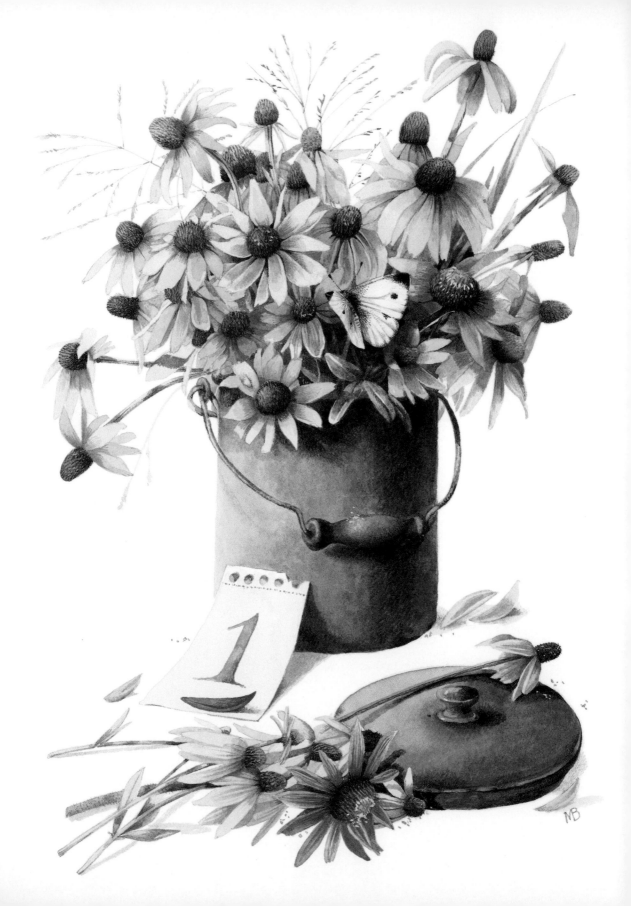

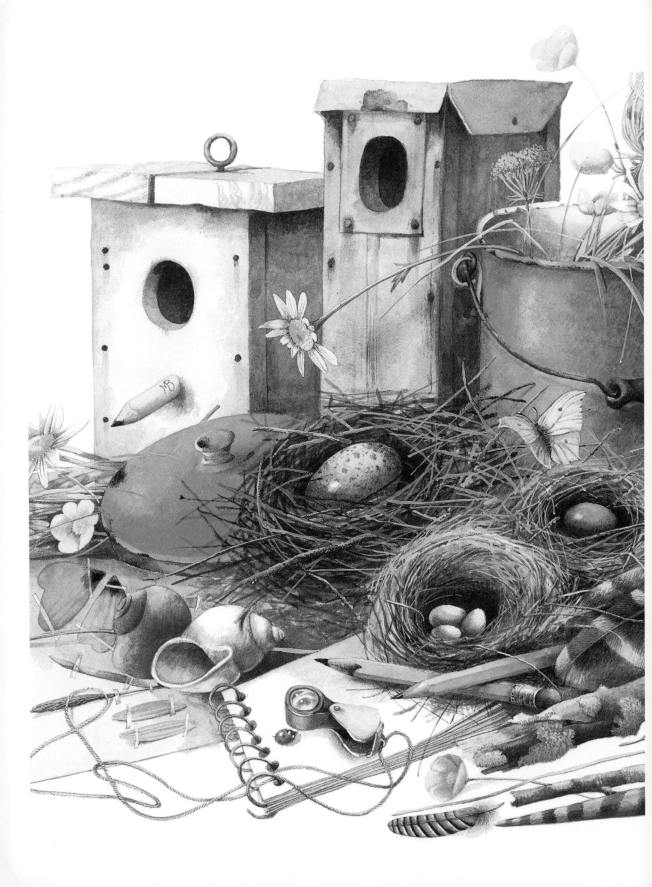

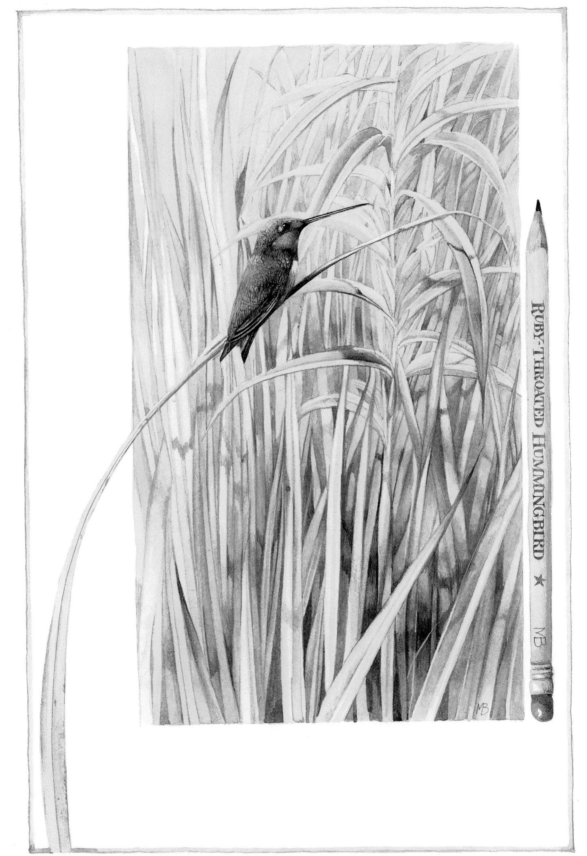

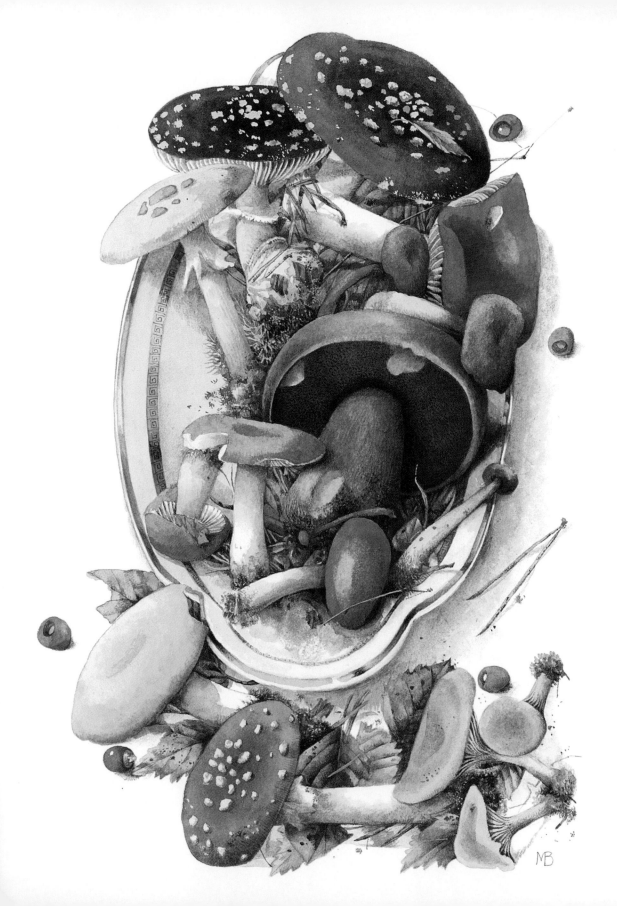

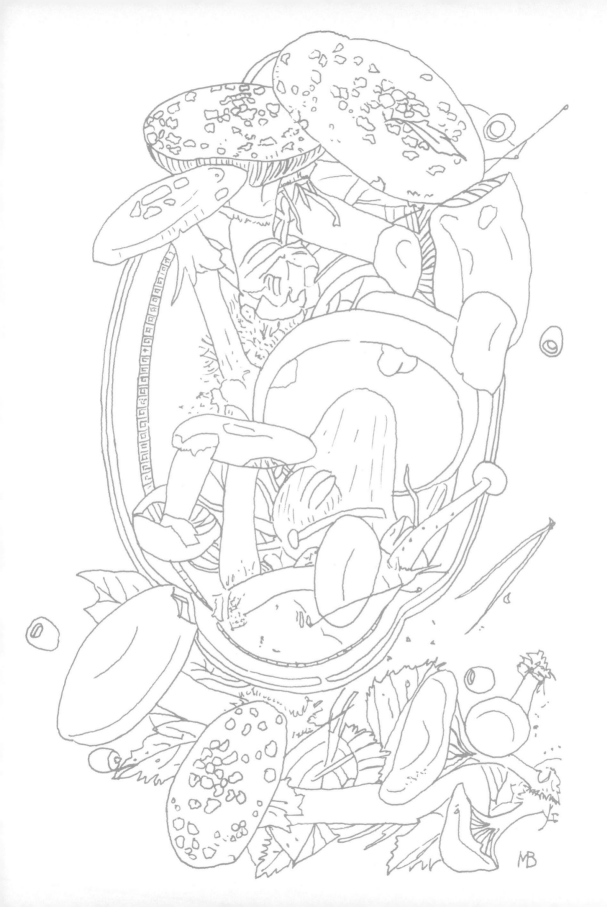

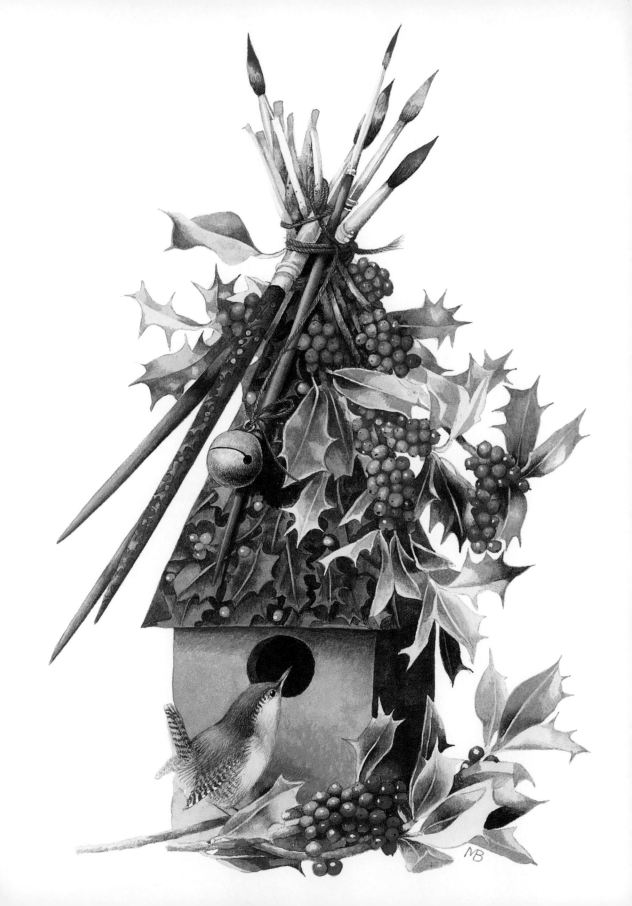

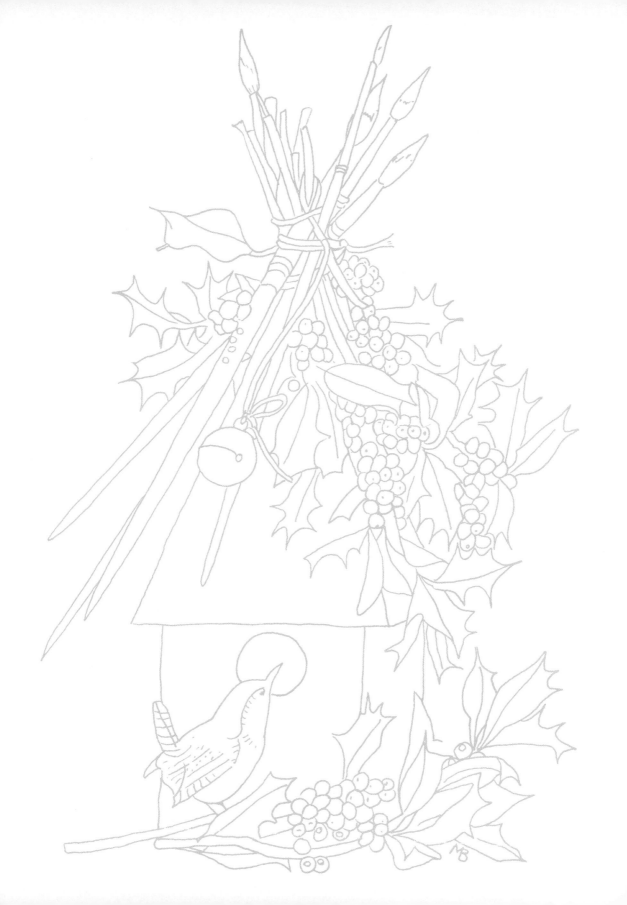

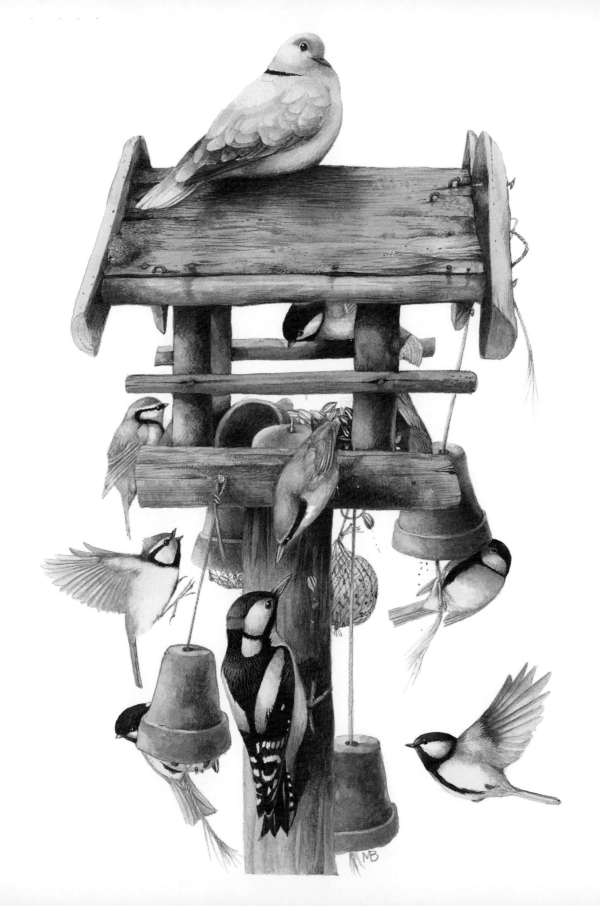

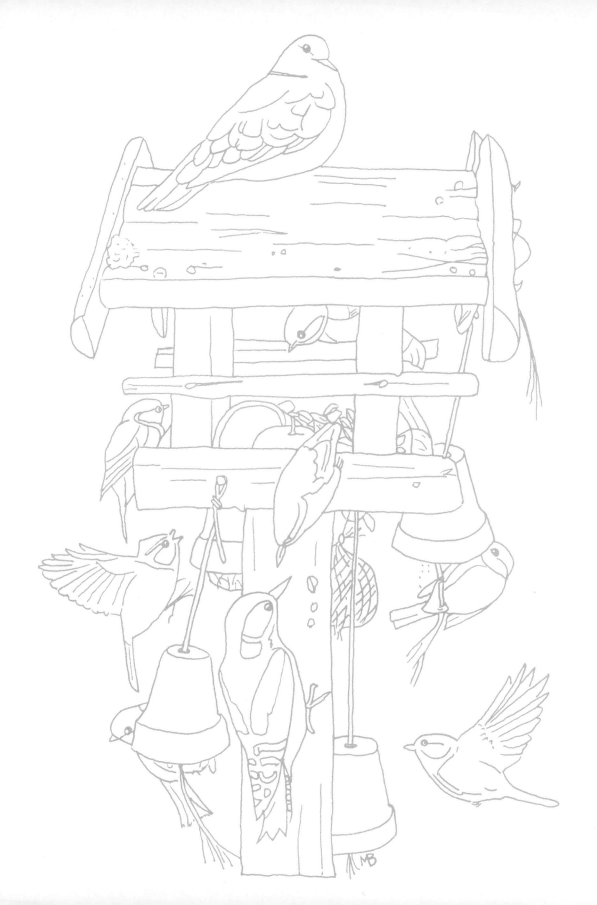

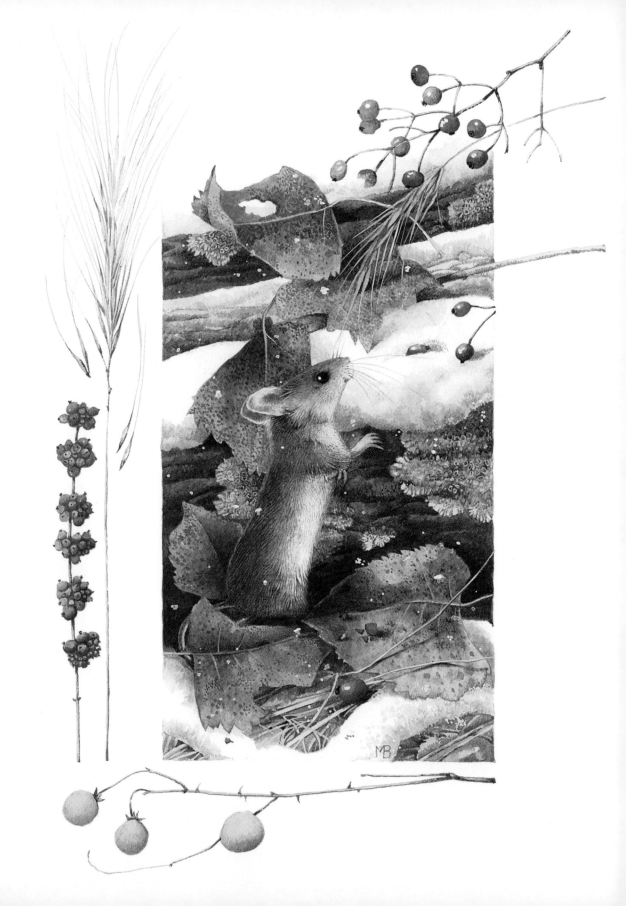

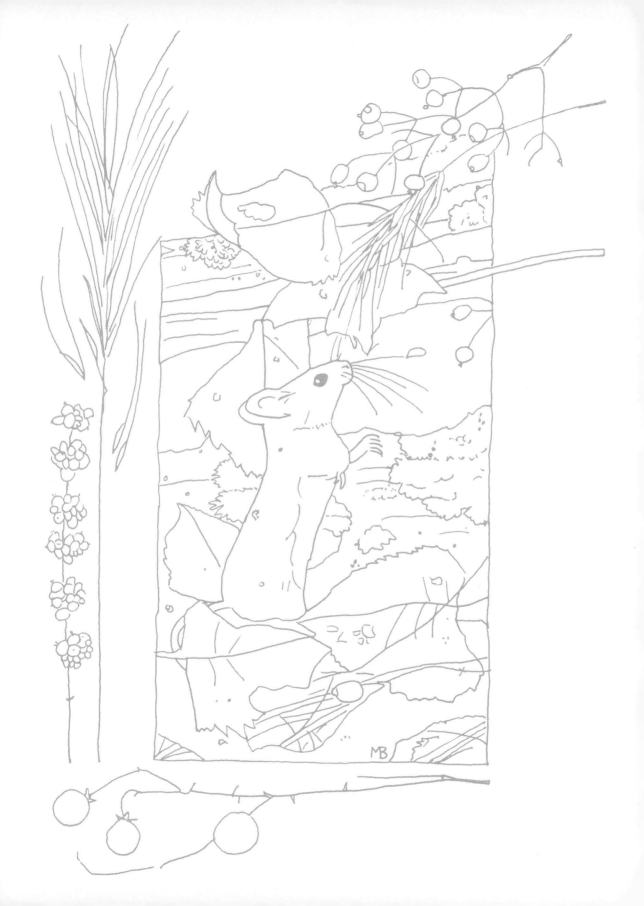

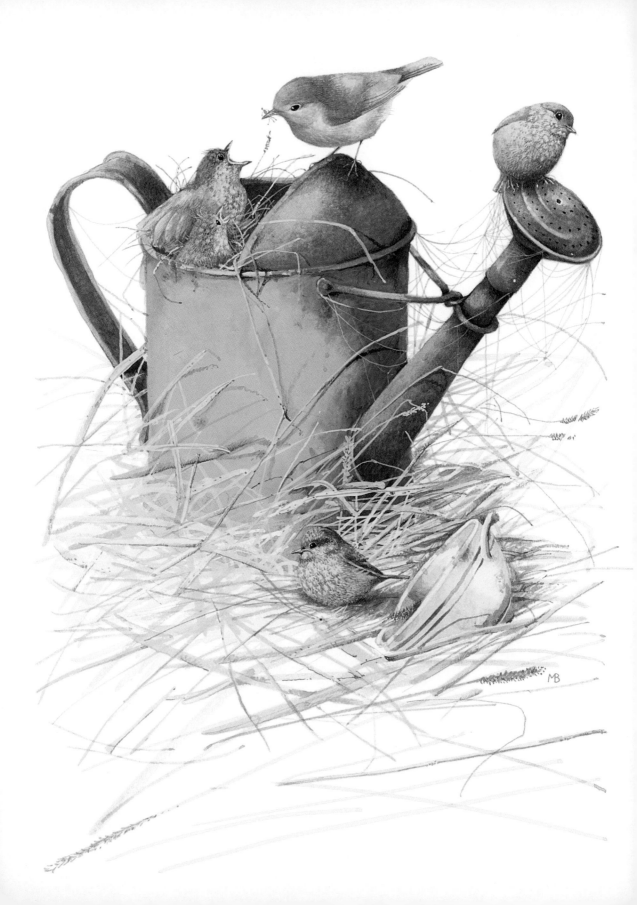

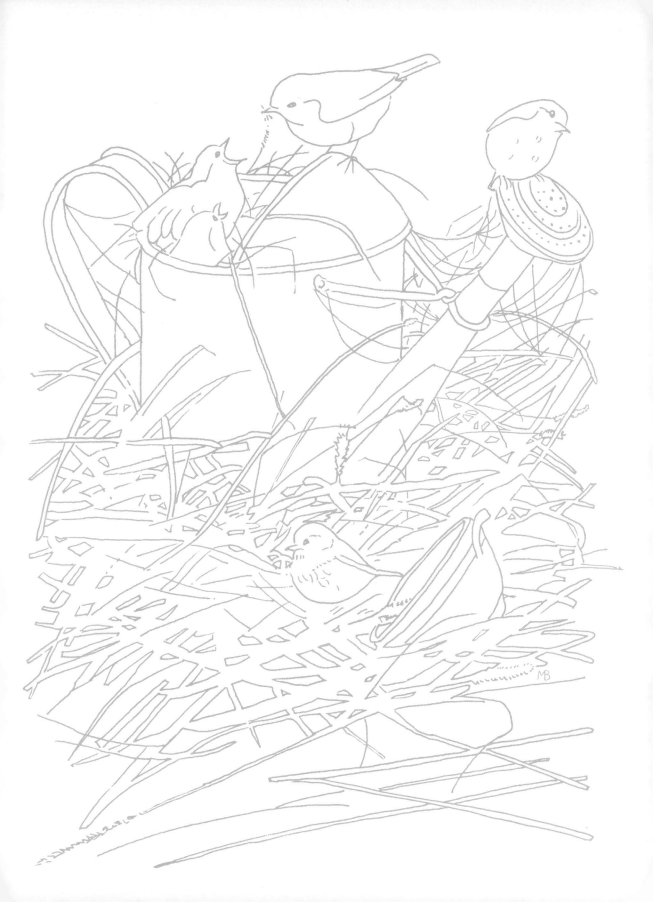

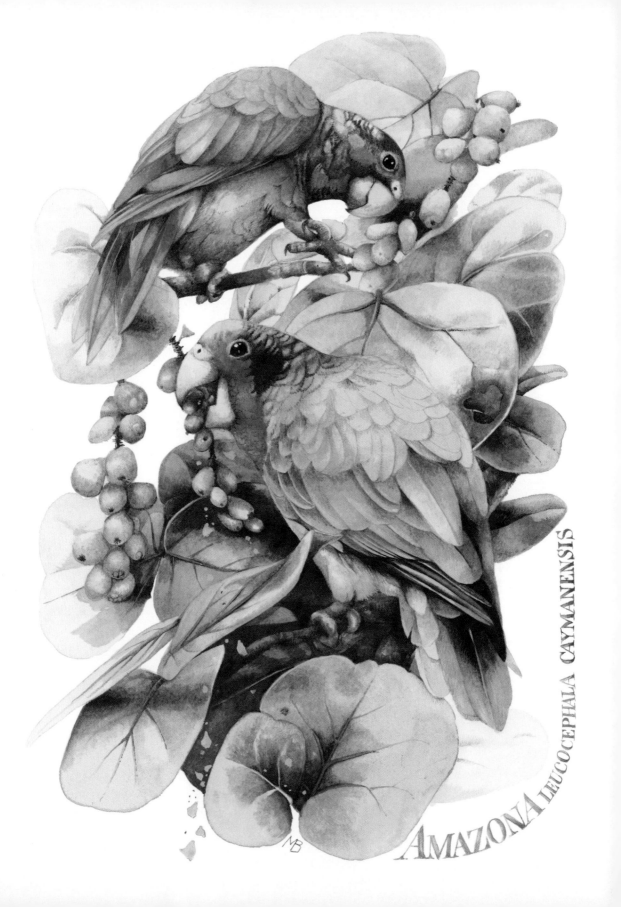

AMAZONA LEUCOCEPHALA CAYMANENSIS

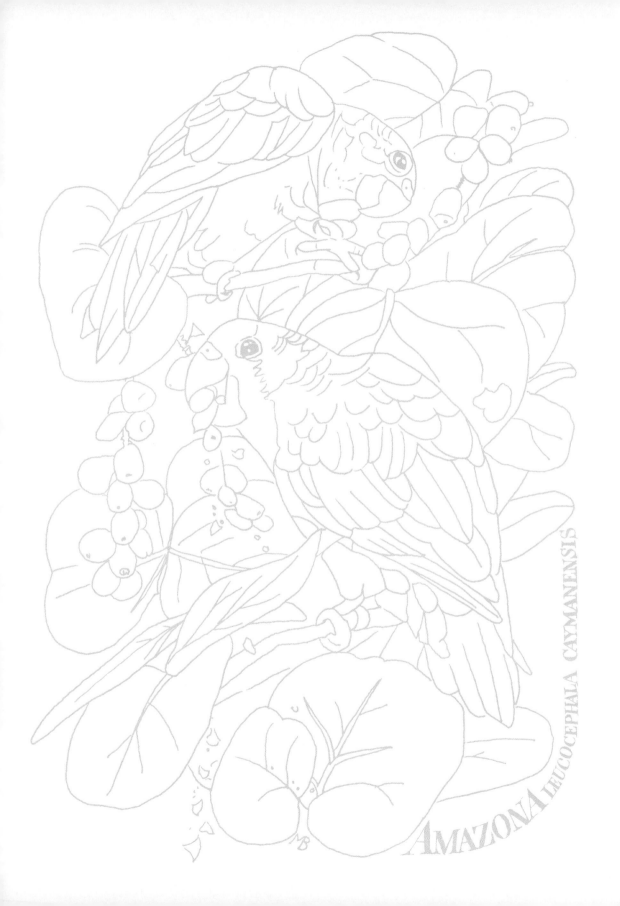
AMAZONA LEUCOCEPHALA CAYMANENSIS

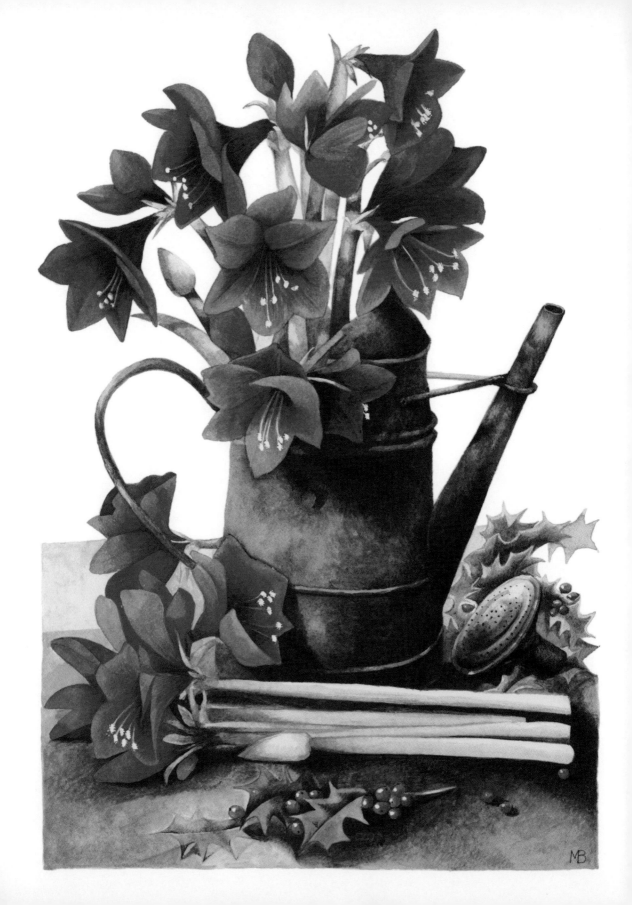

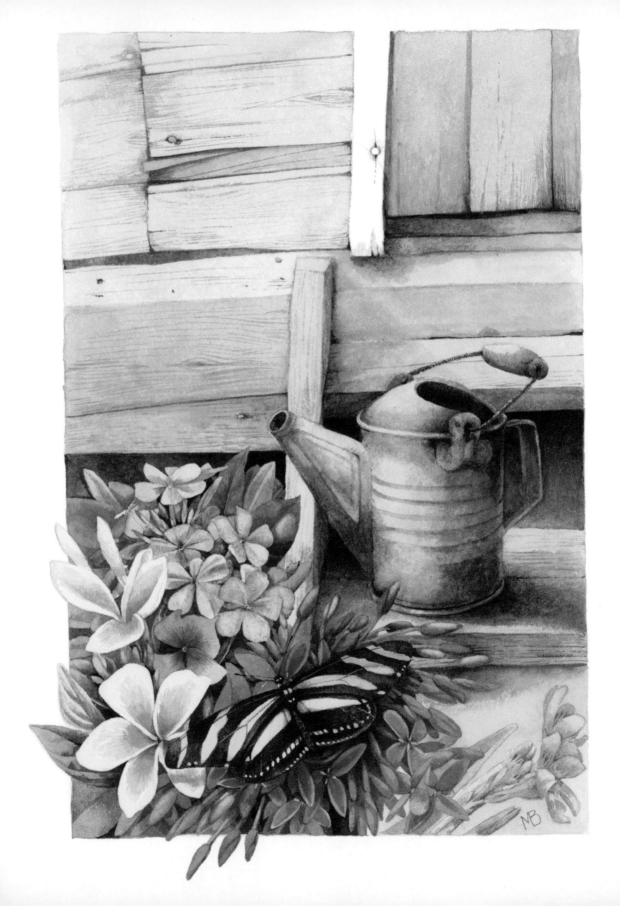

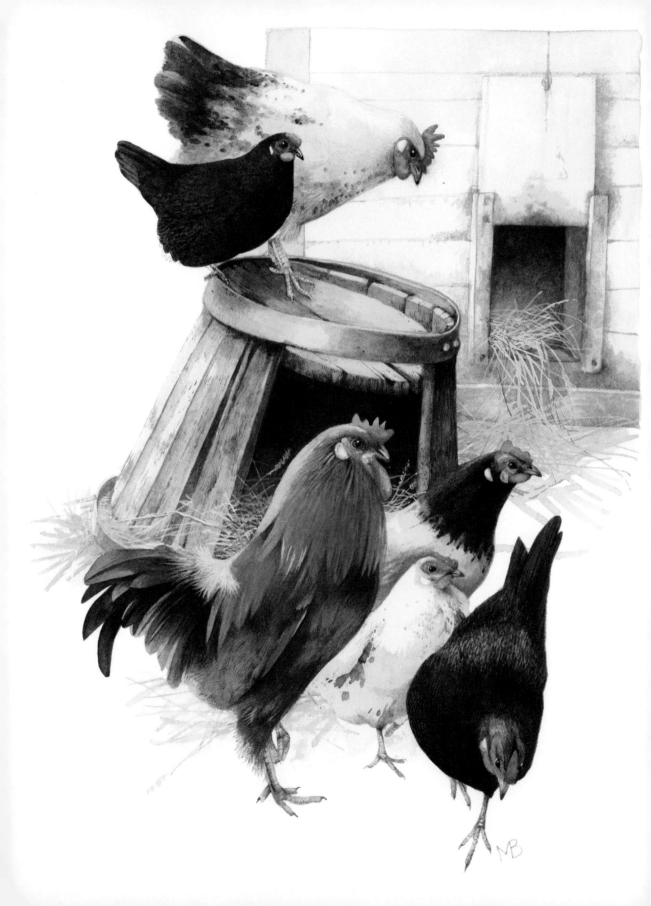

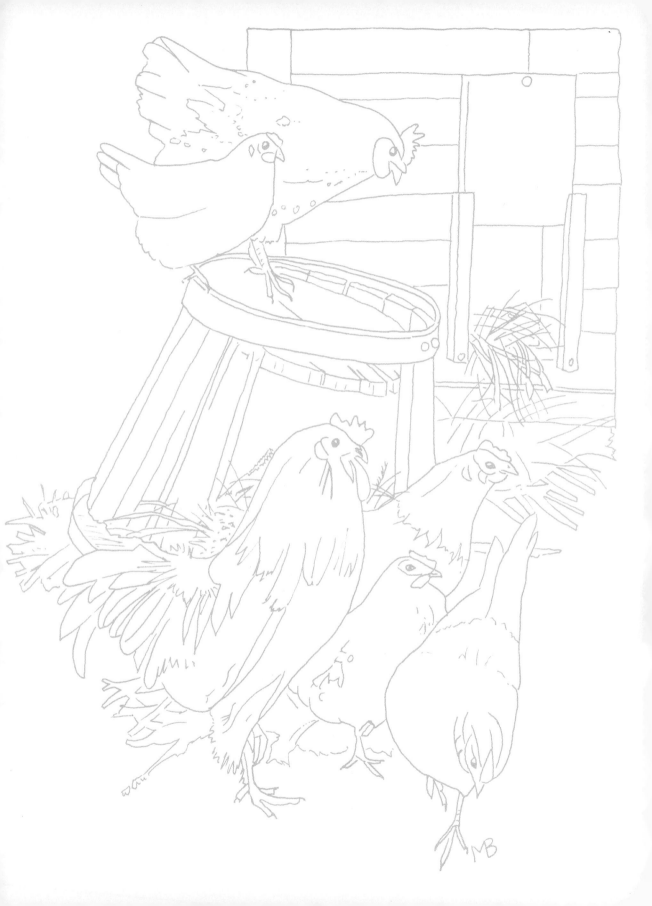

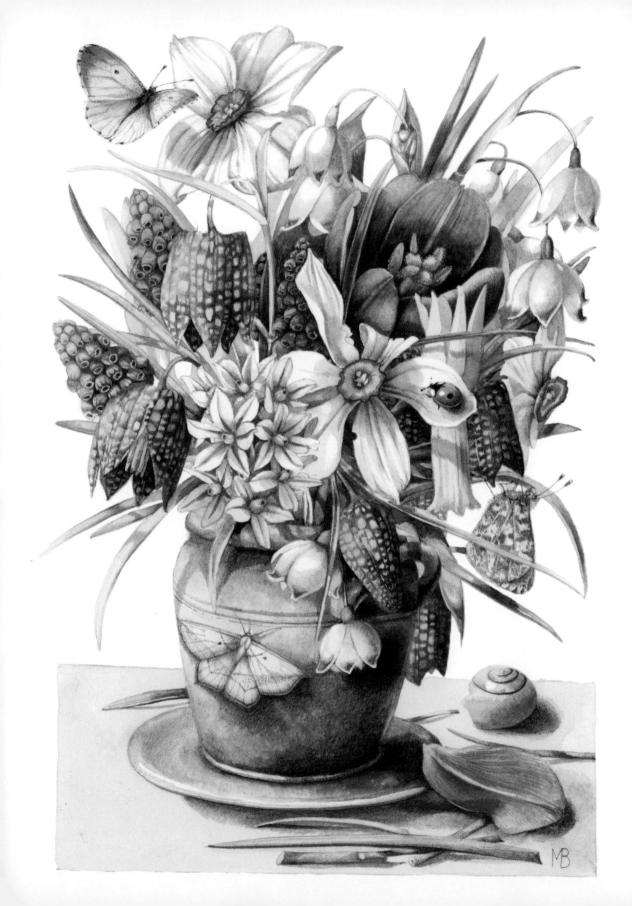

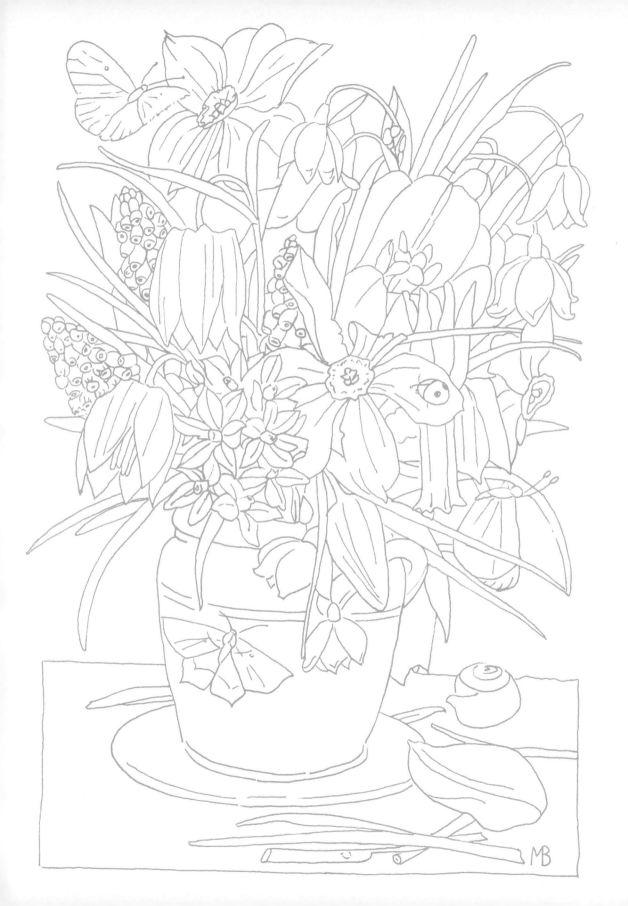

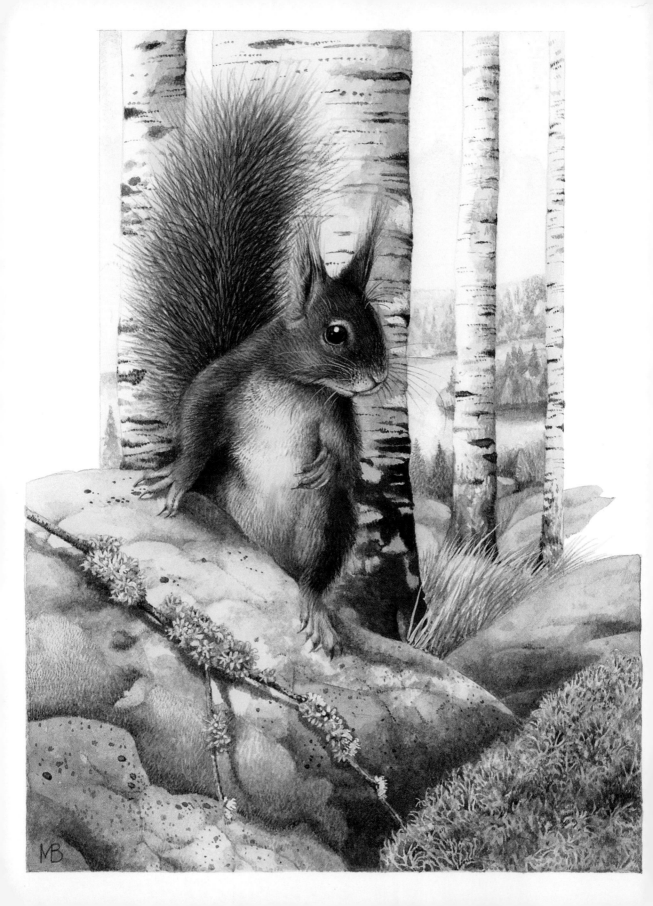

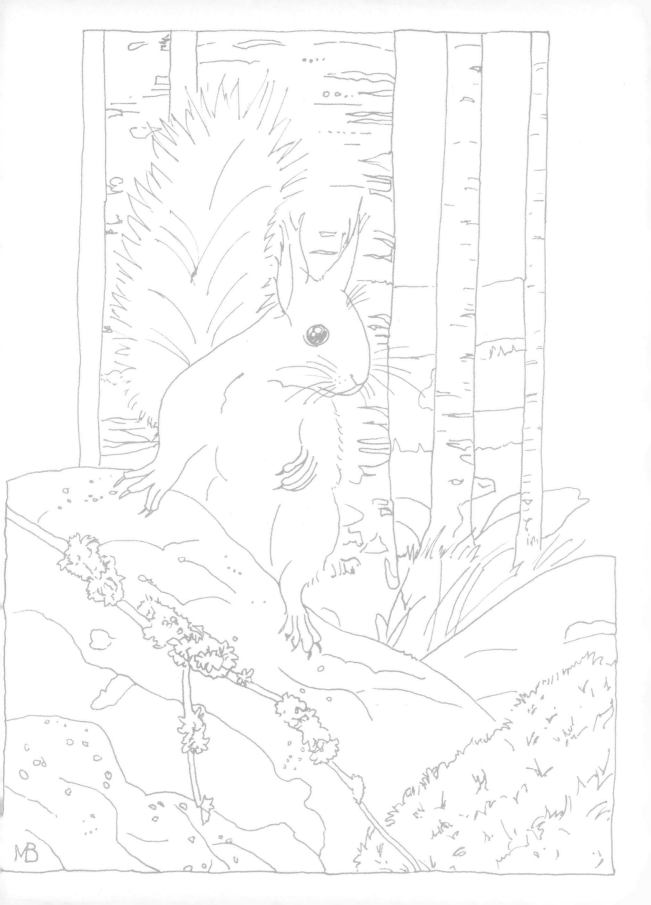

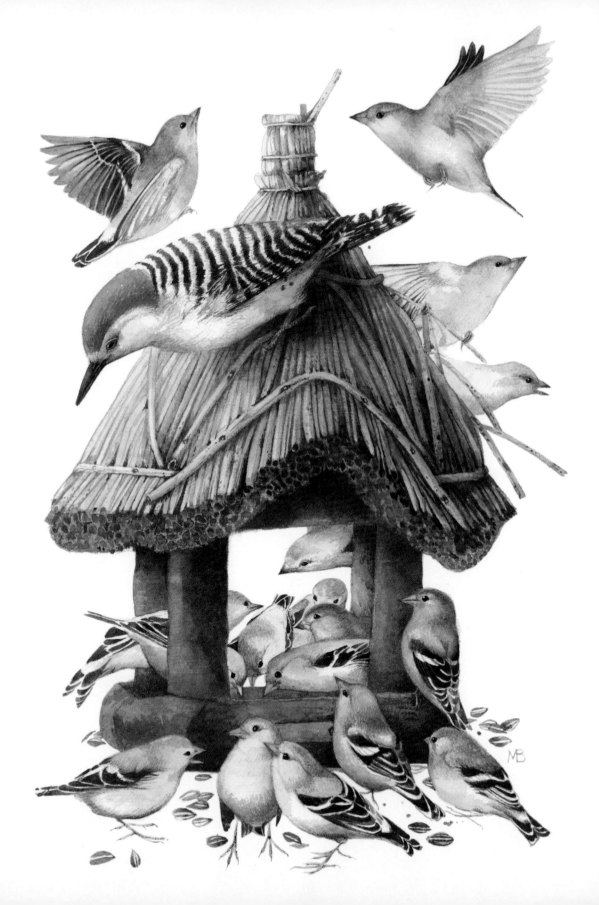

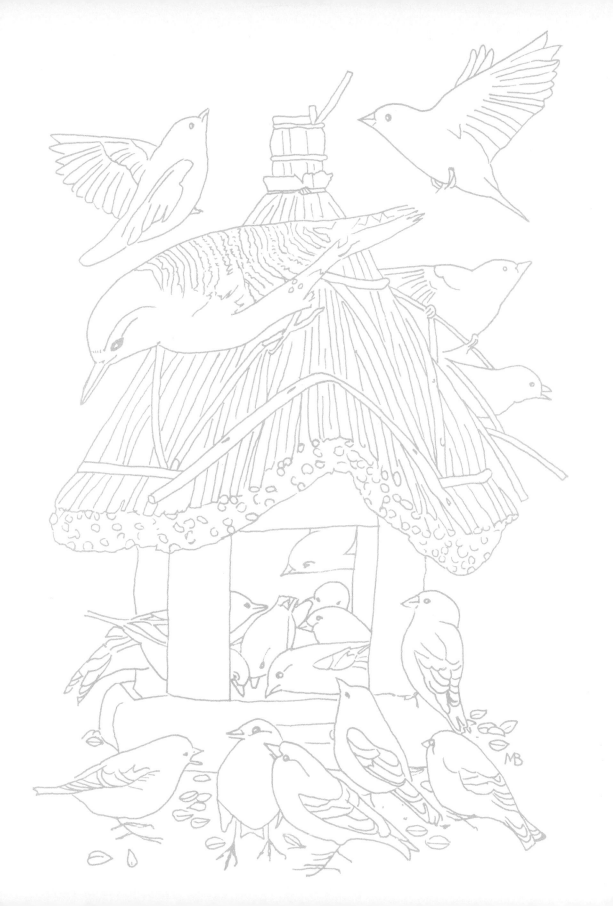

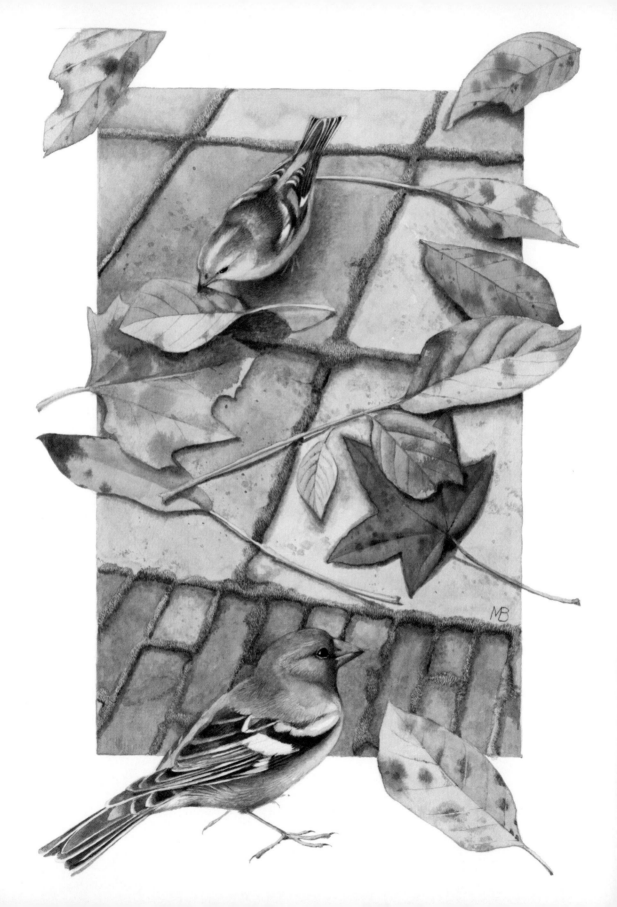

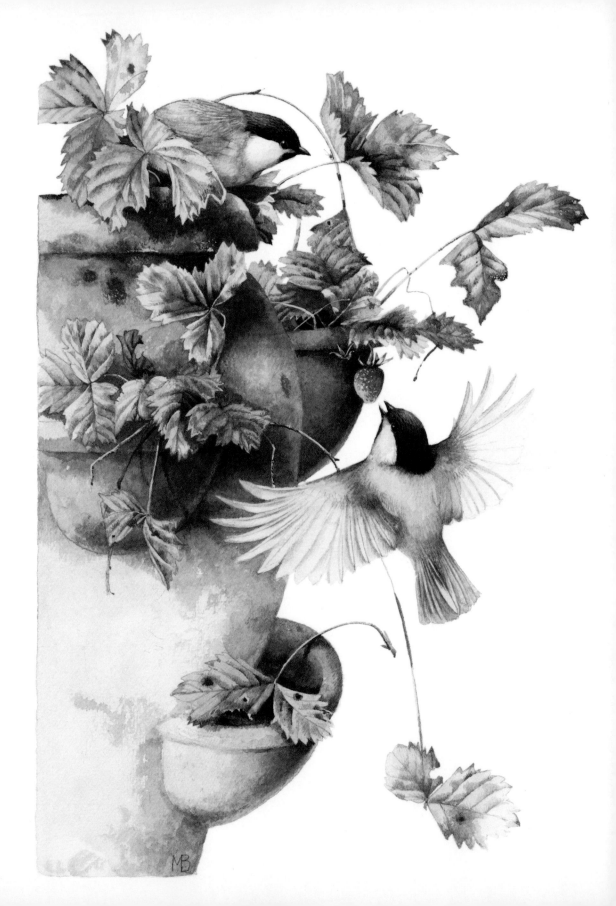

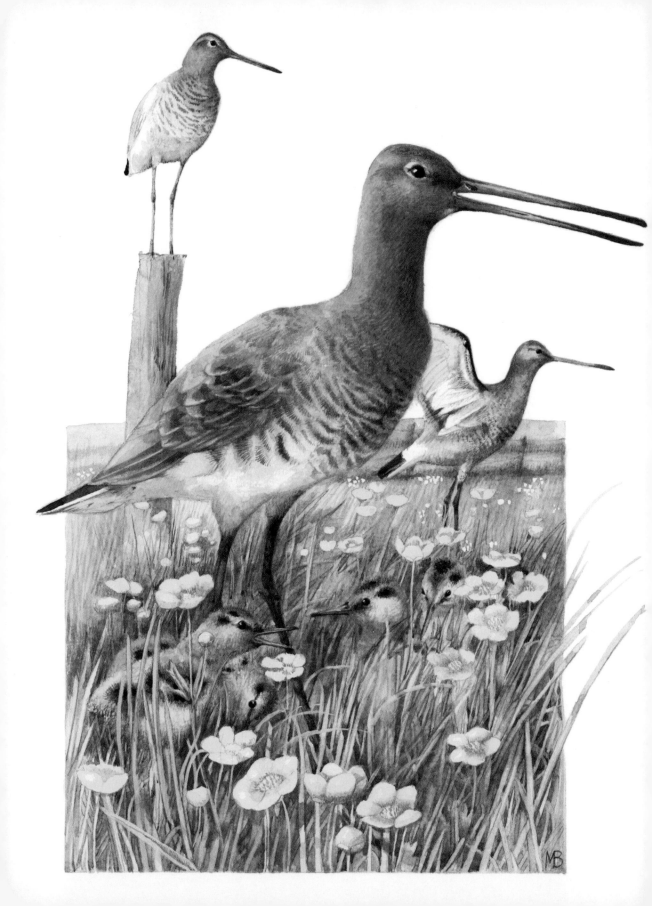

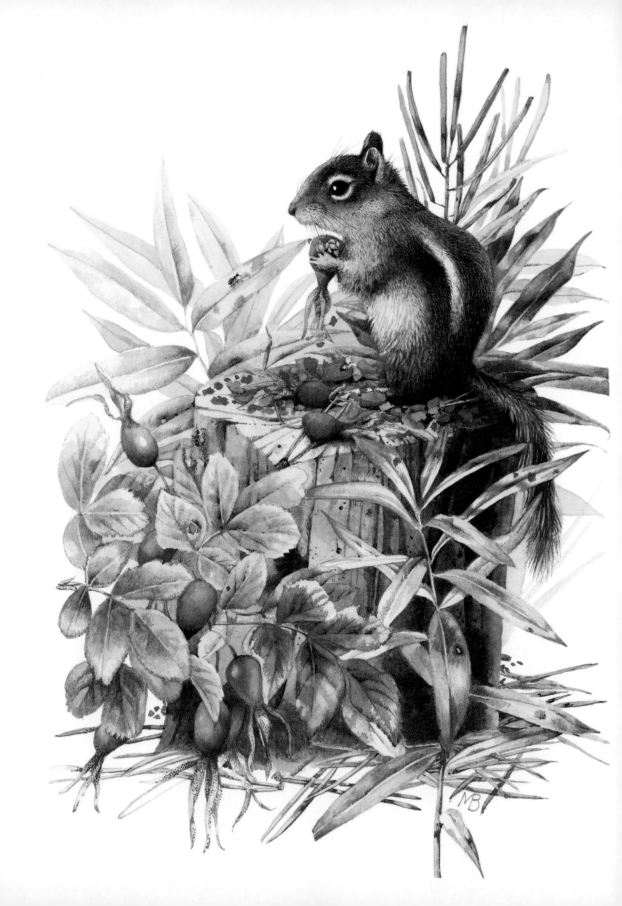

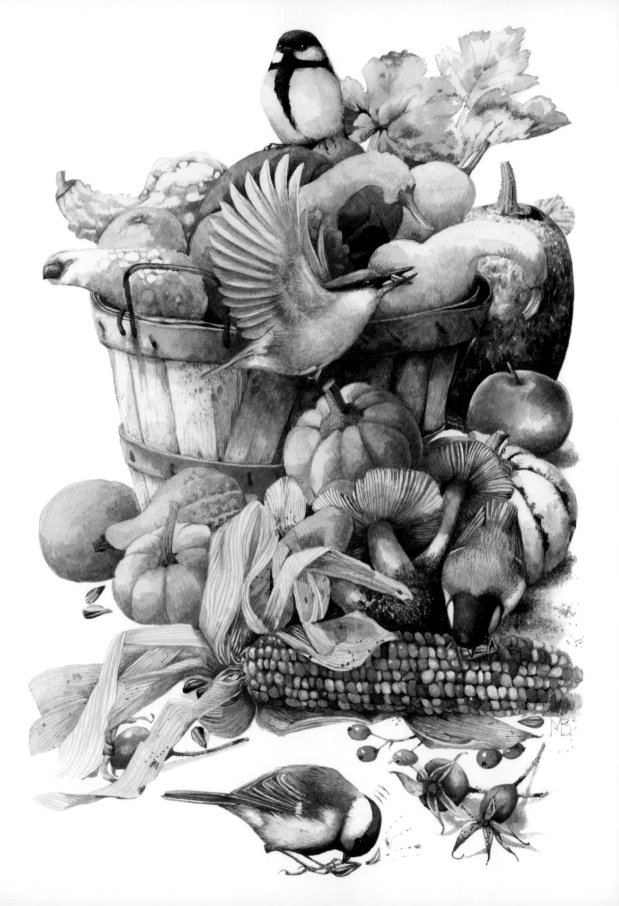

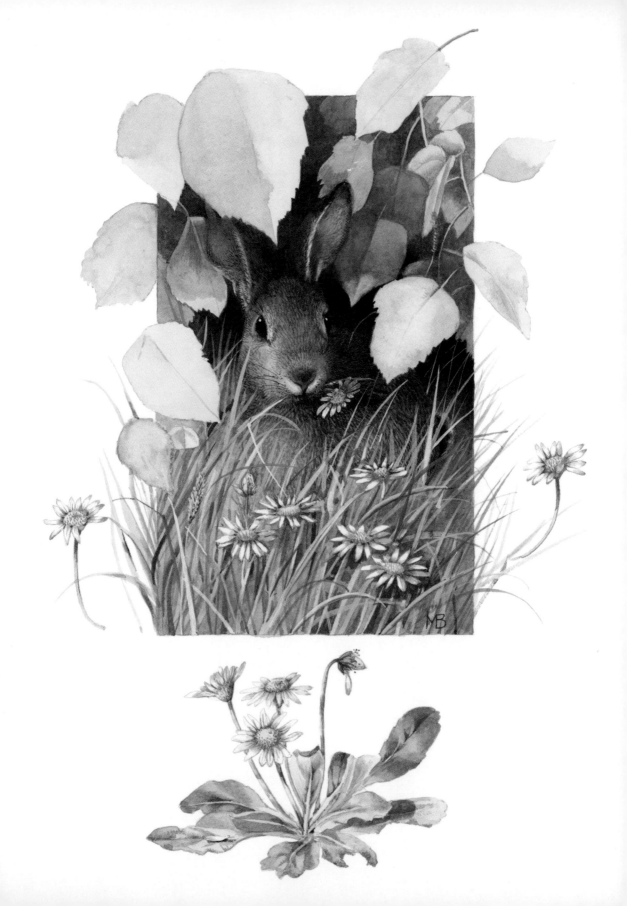

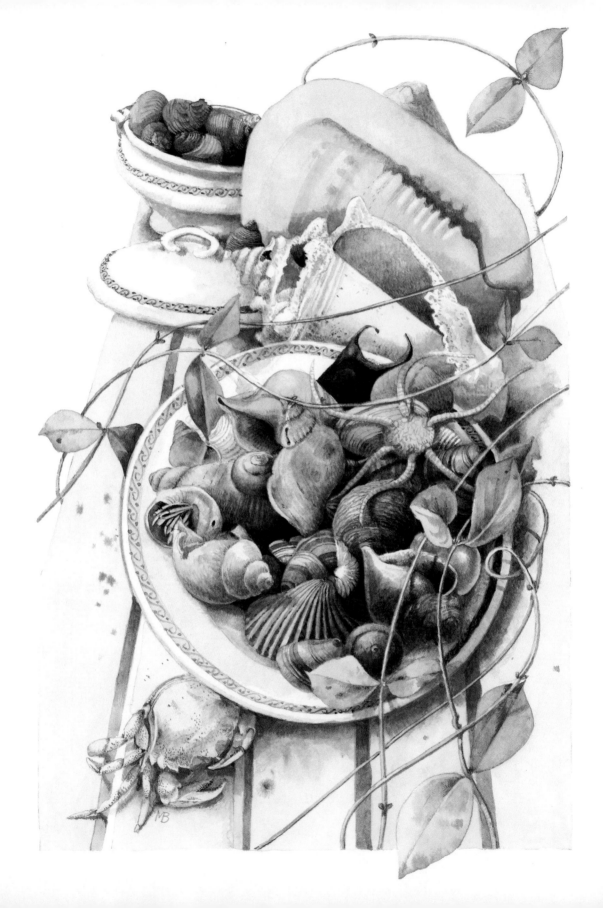

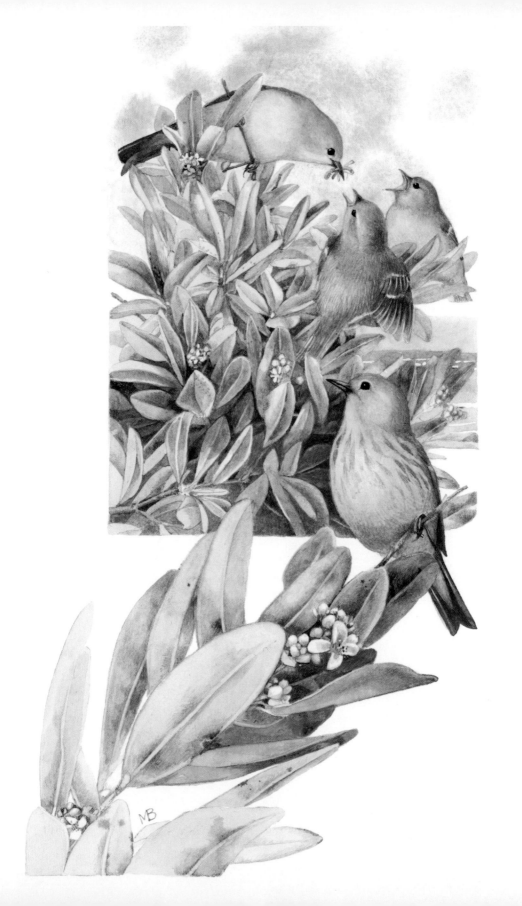

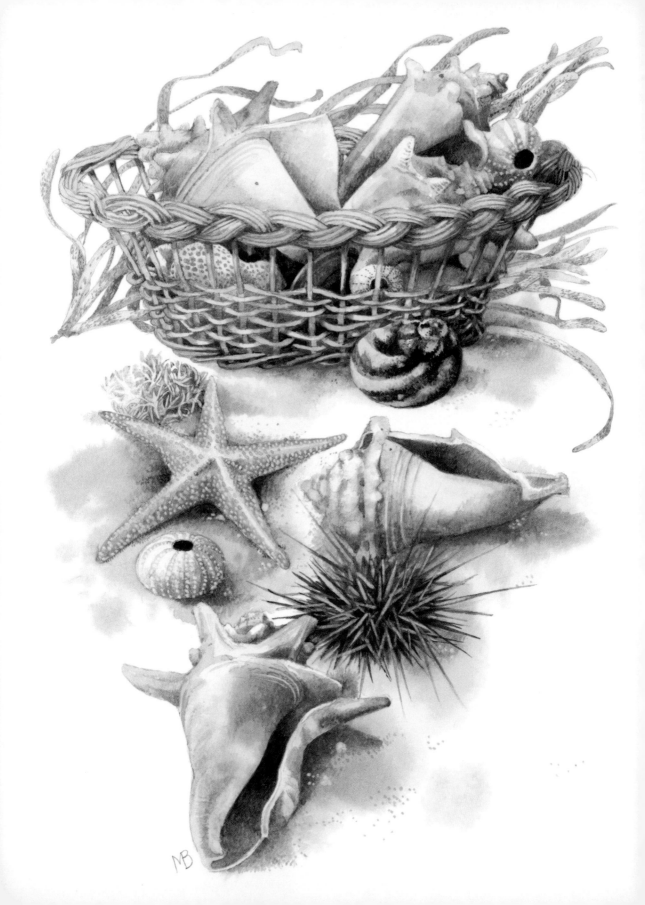

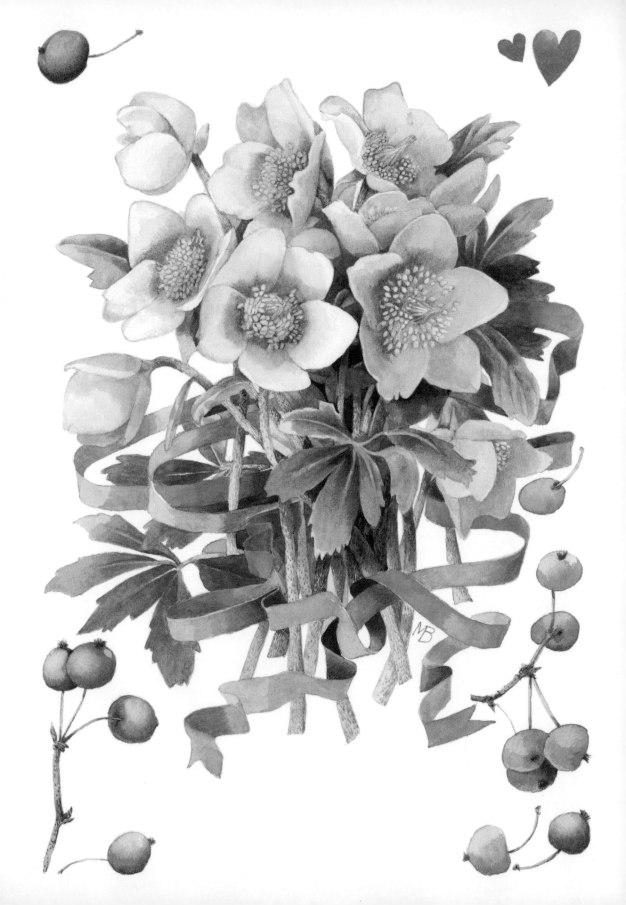

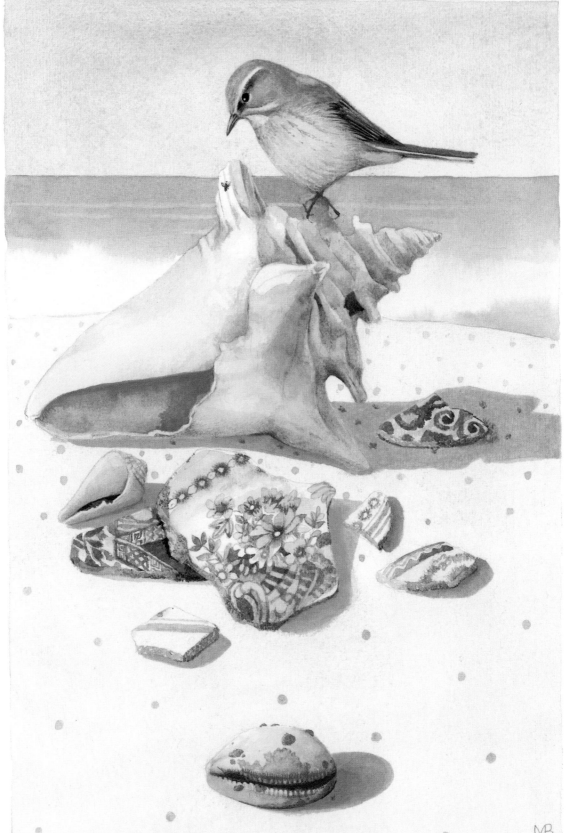

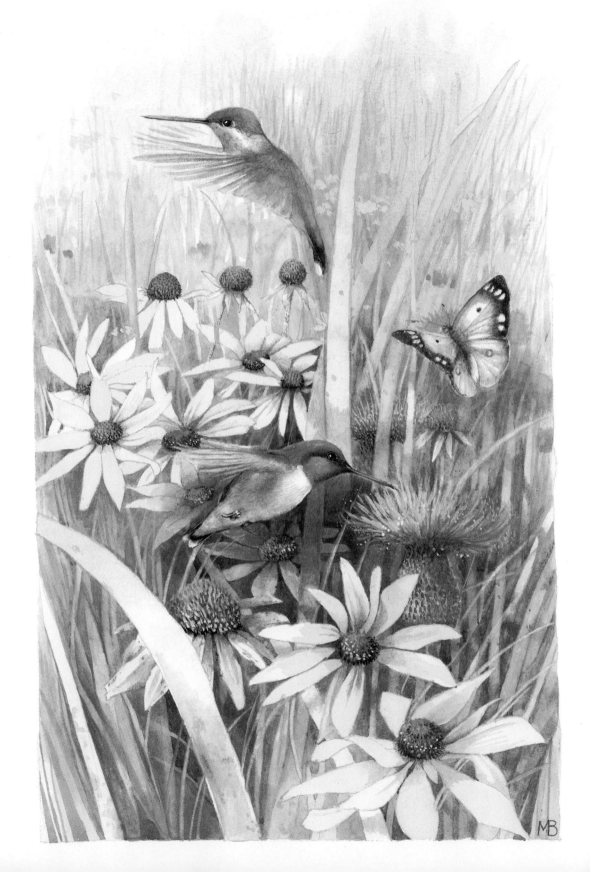

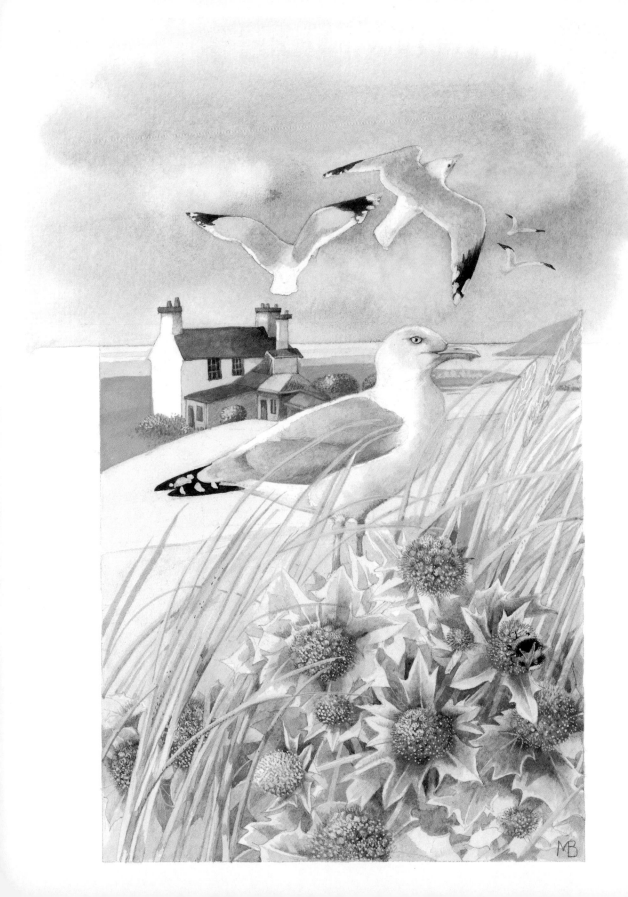

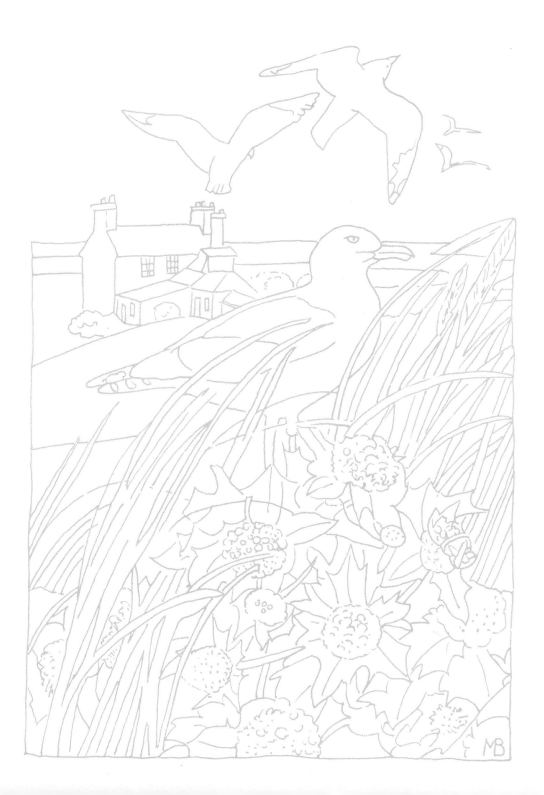

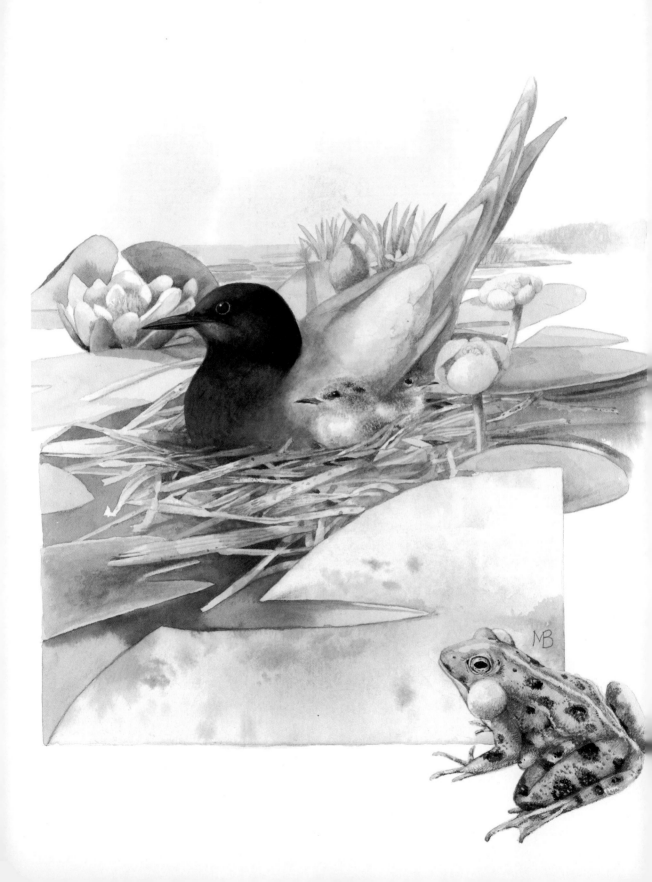

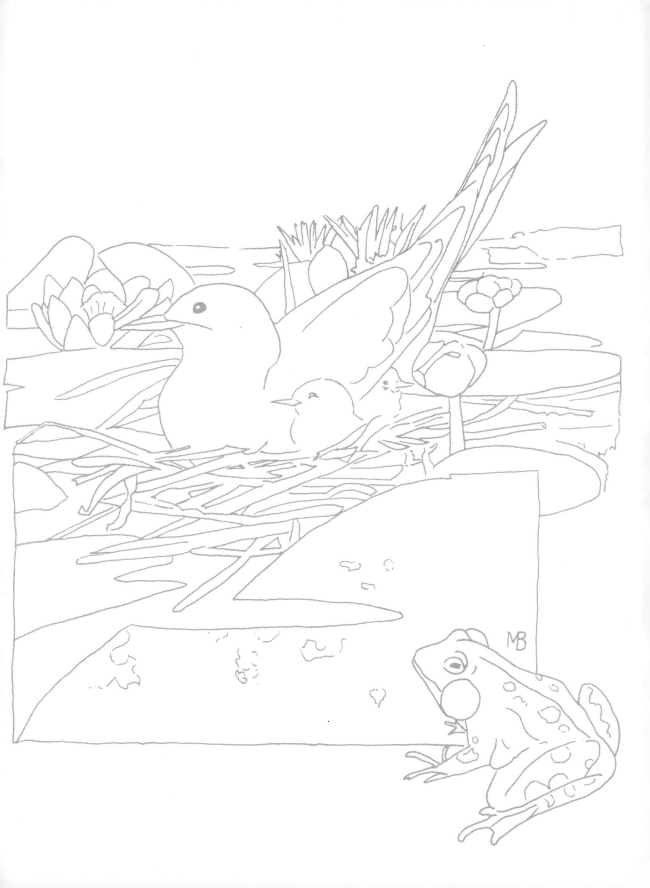

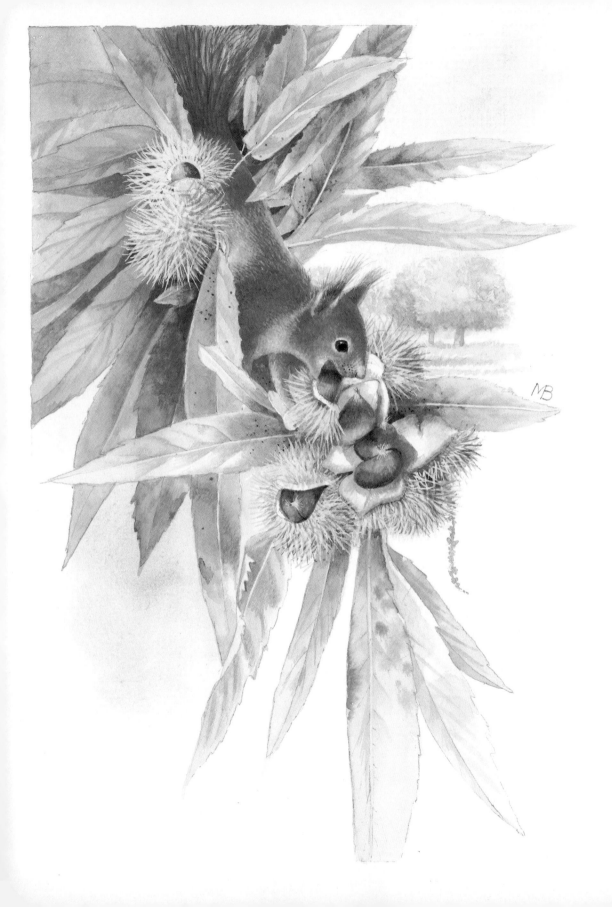

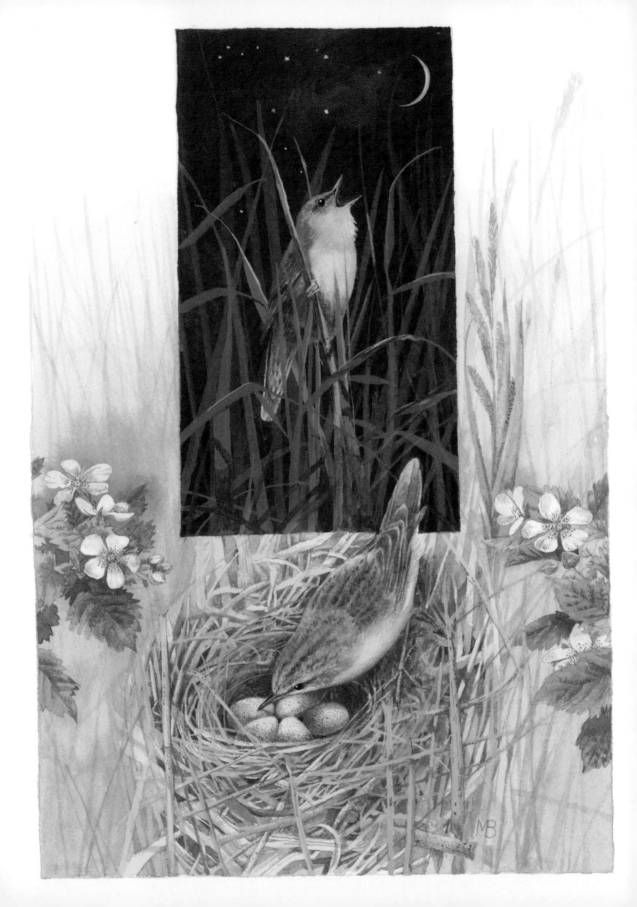

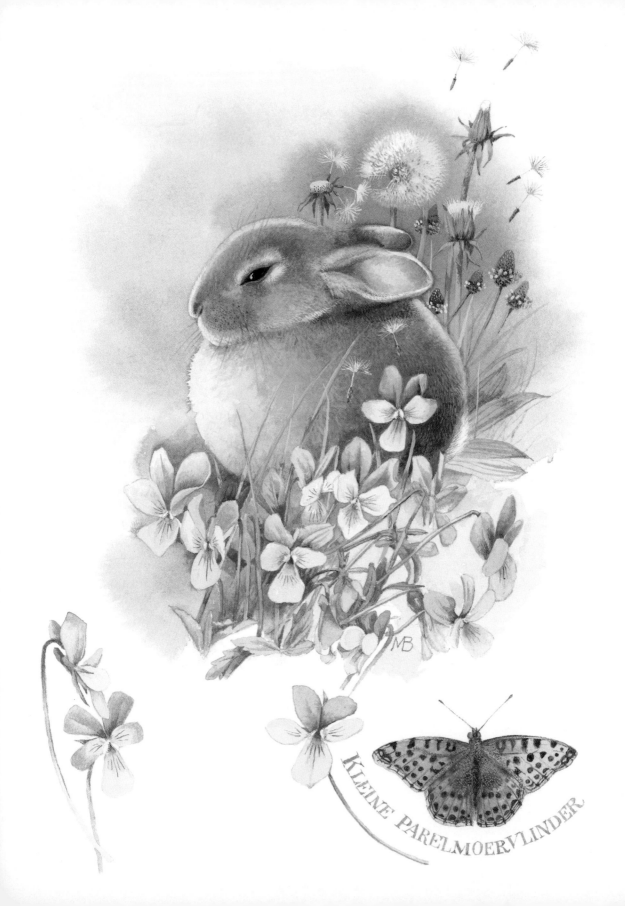

KLEINE PARELMOERVLINDER

KLEINE PARELMOERVLINDER

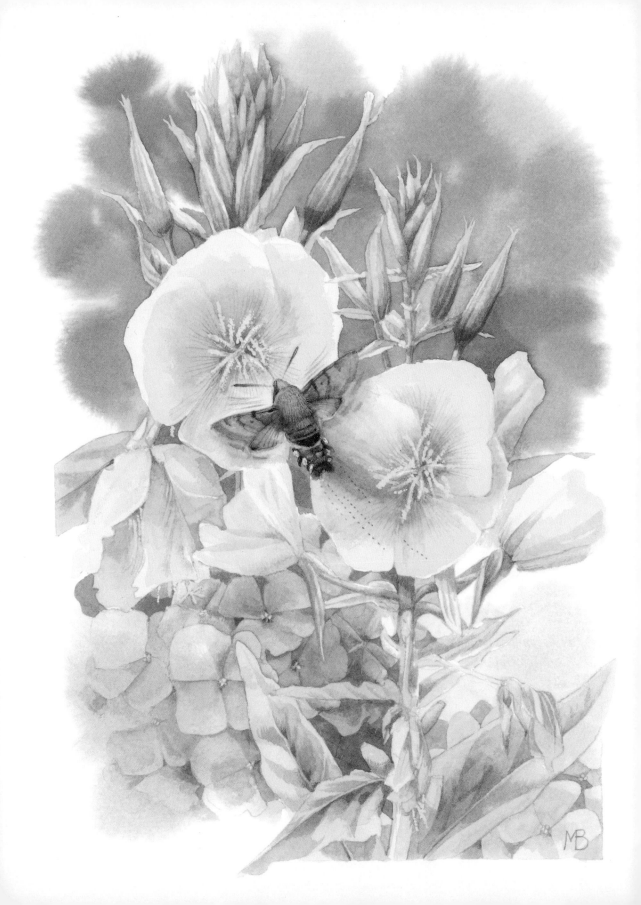

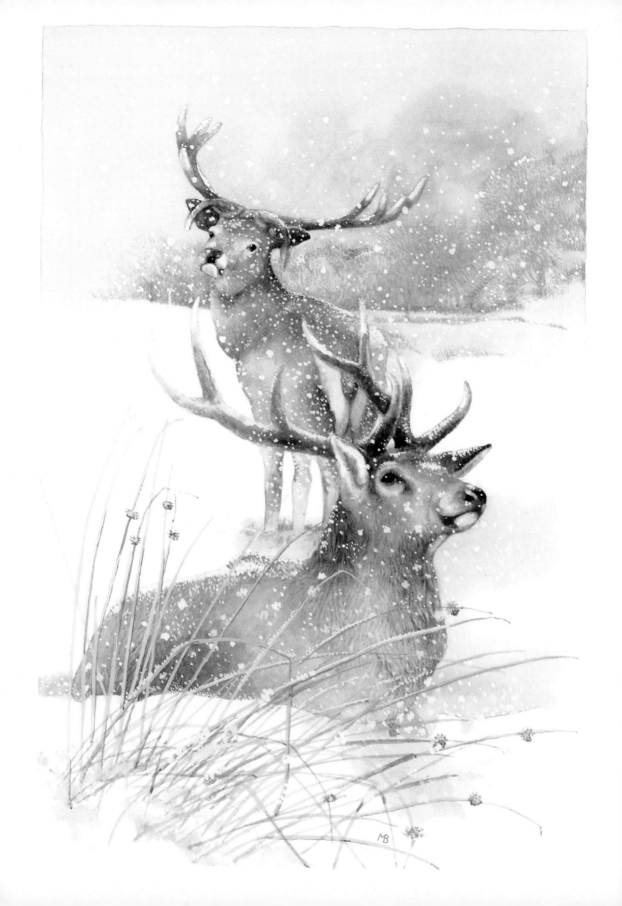

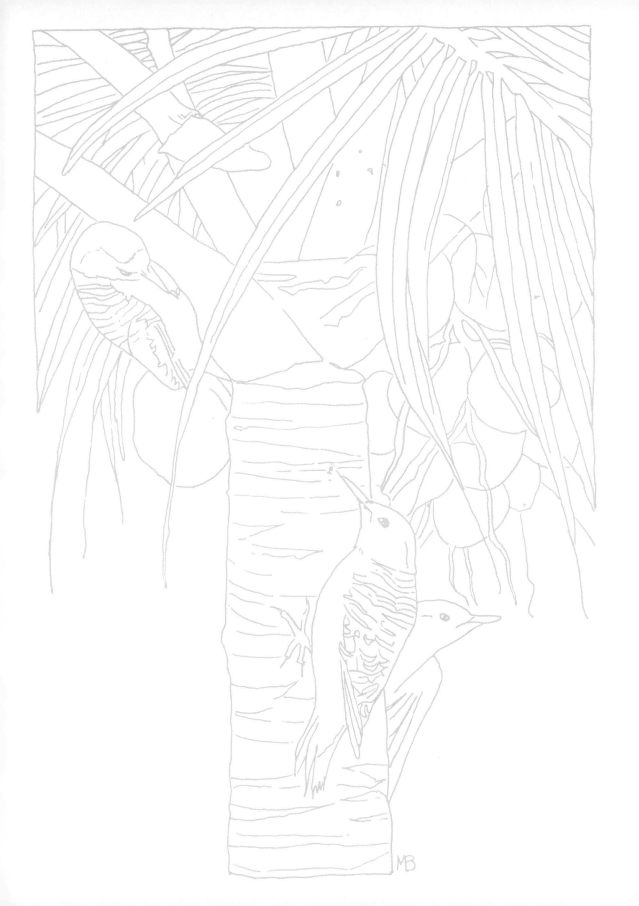

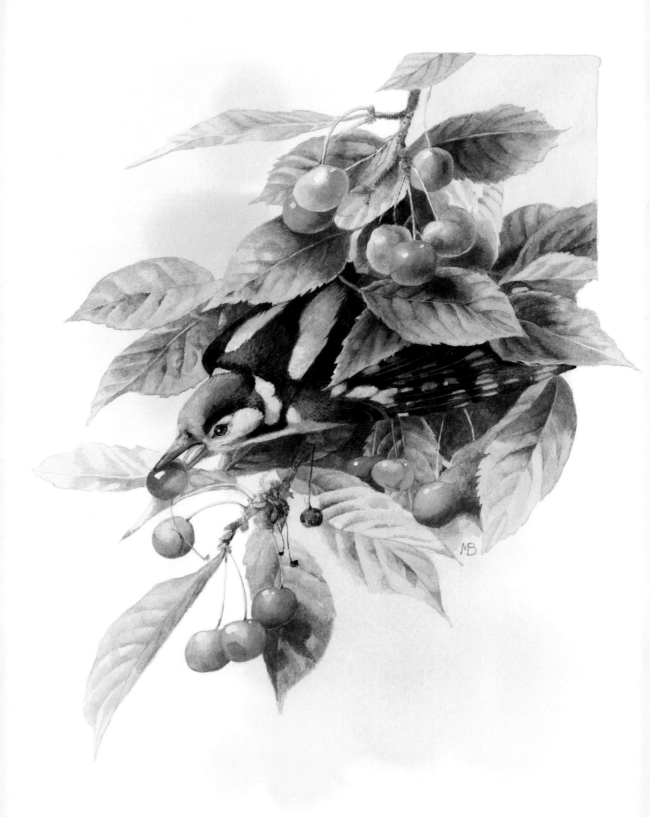

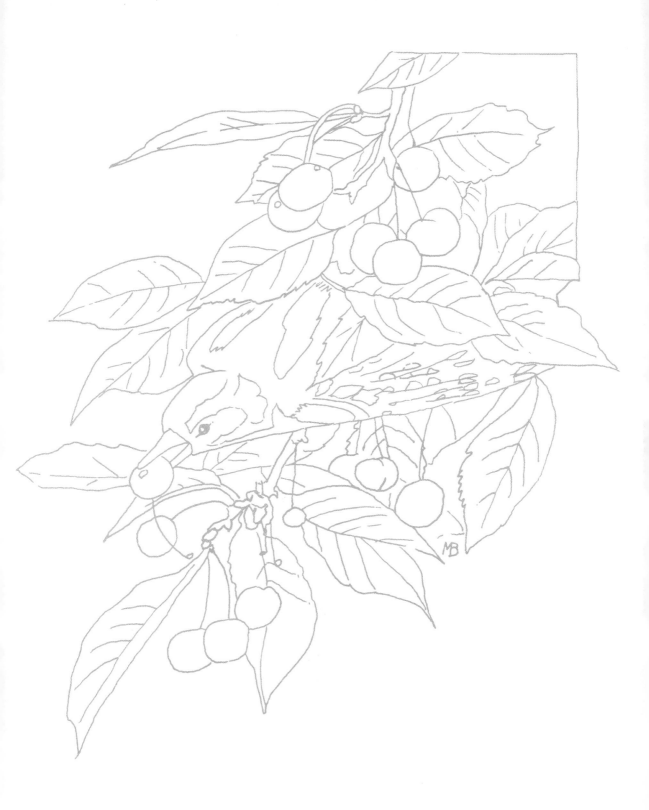

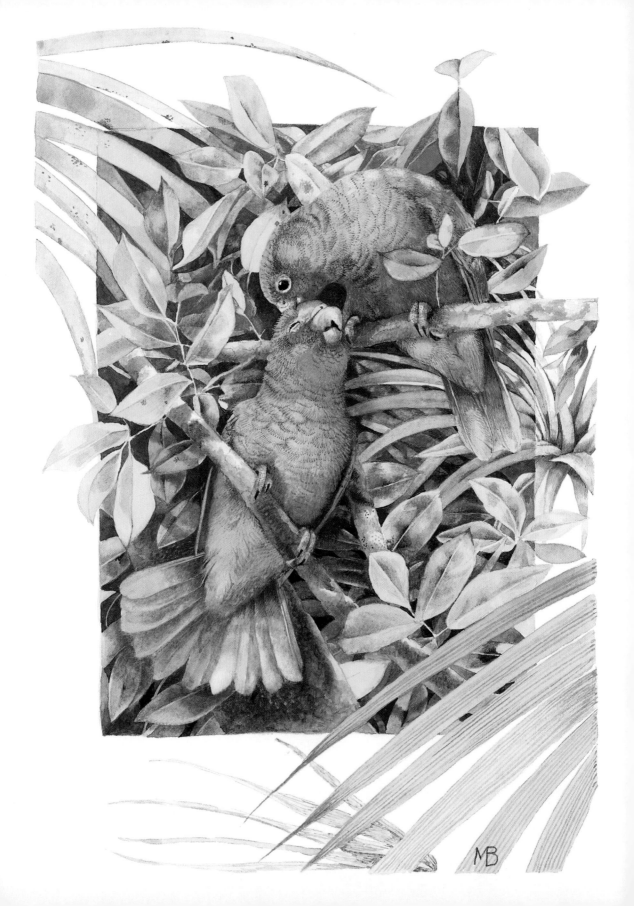

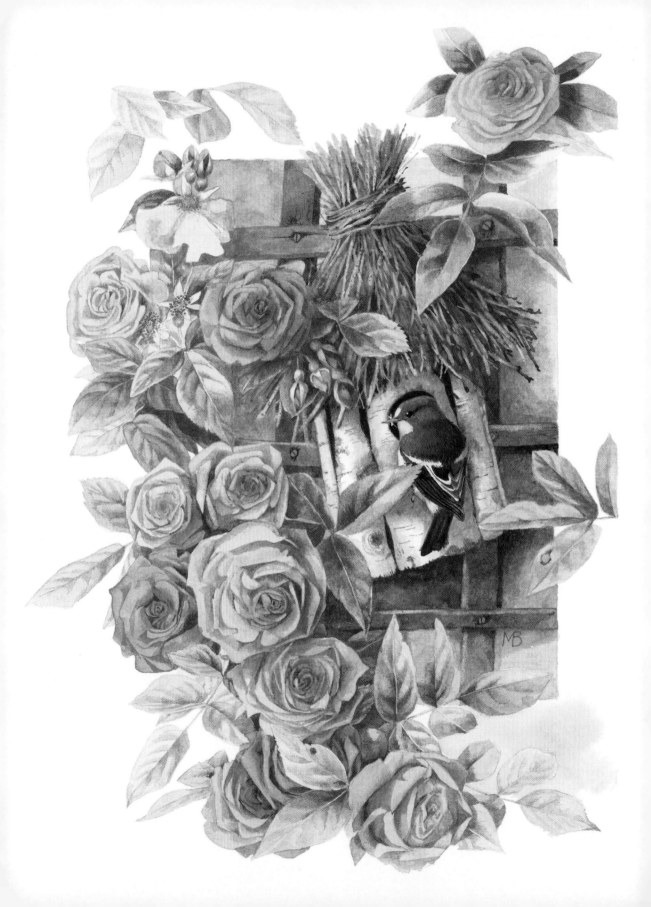

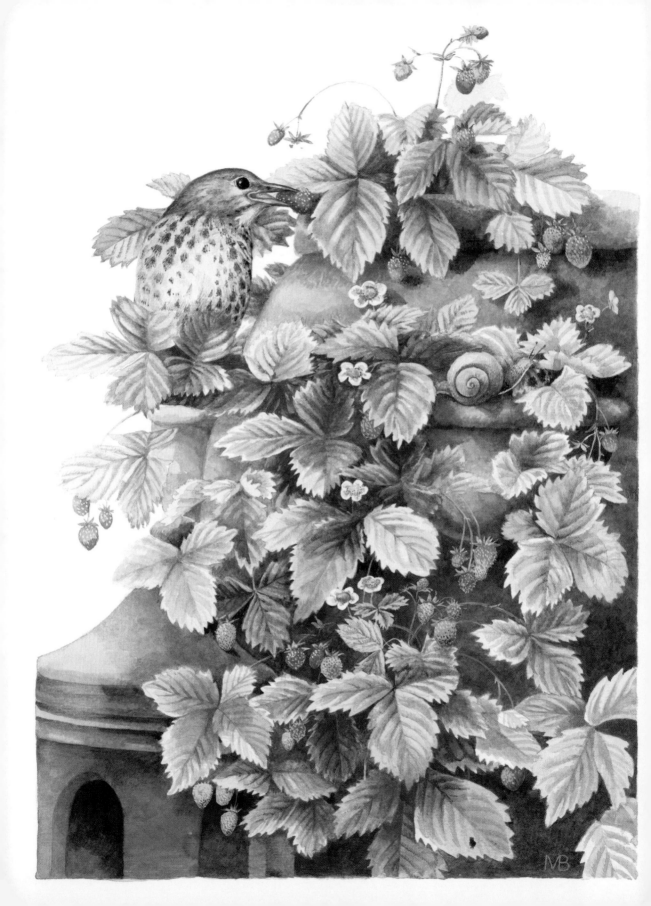

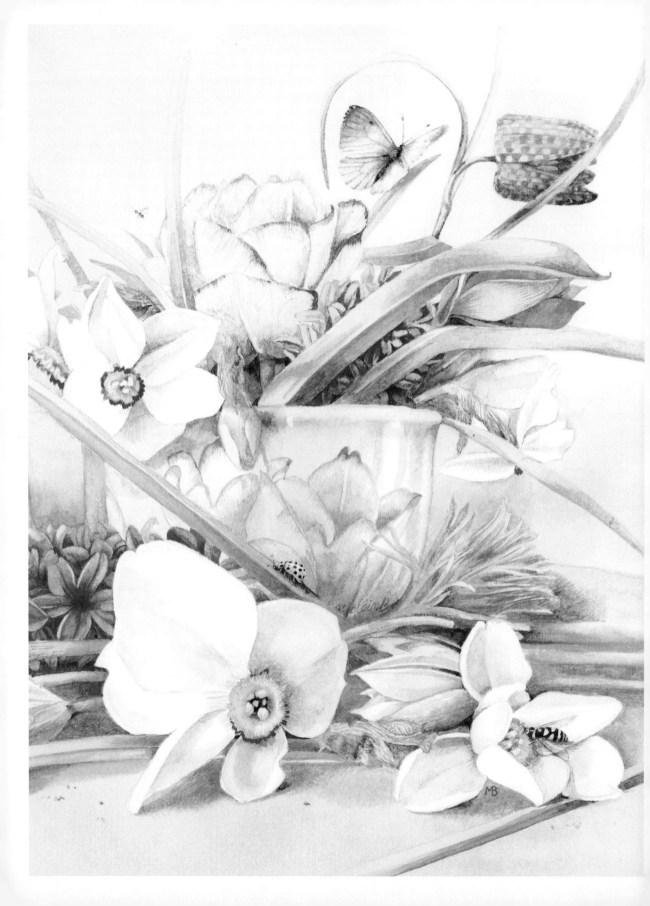

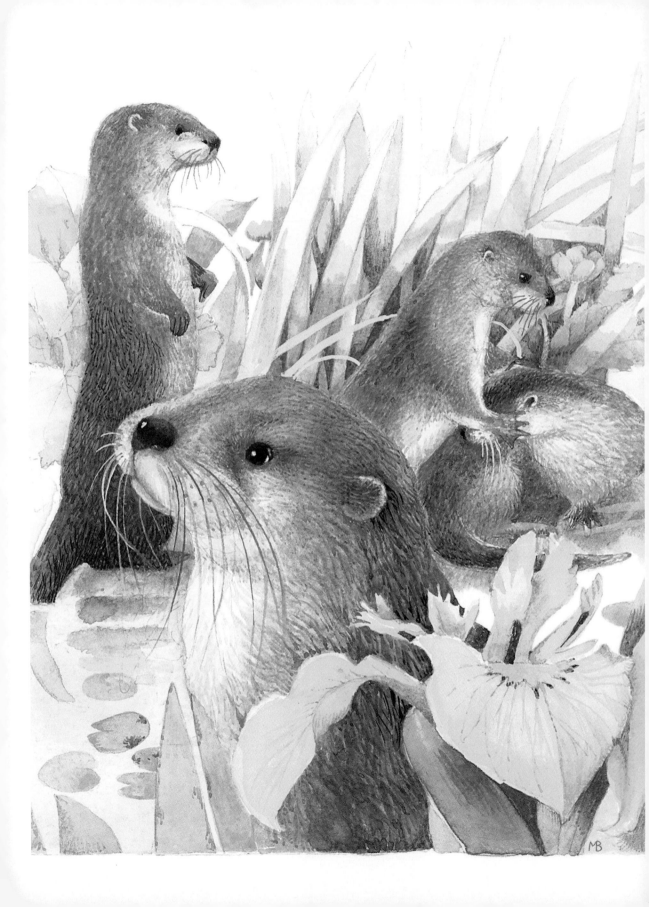

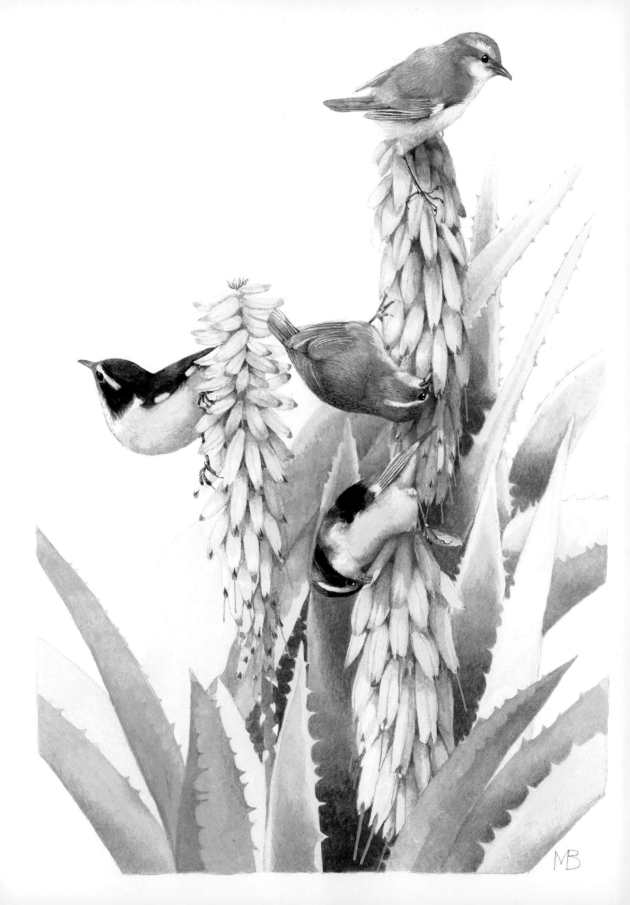

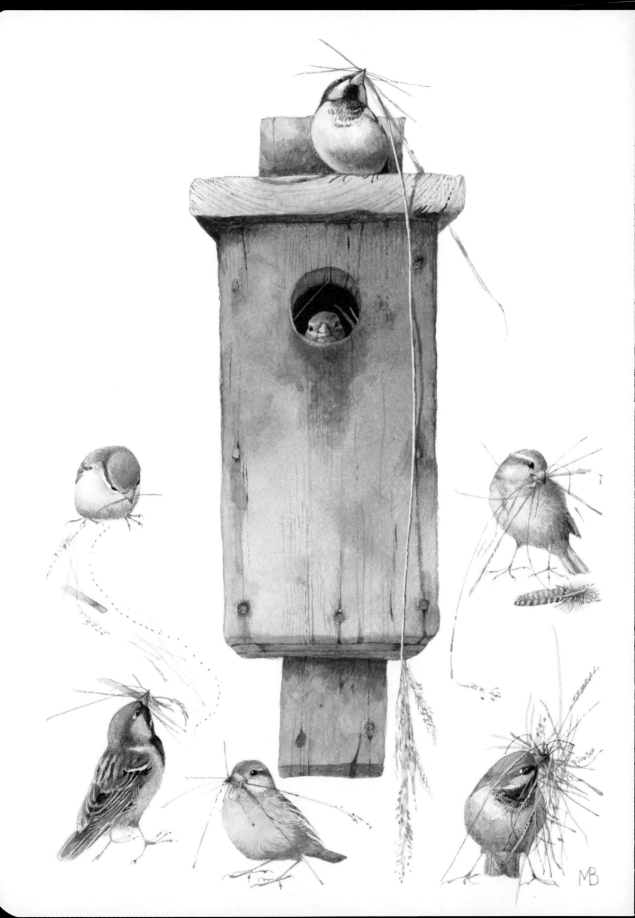

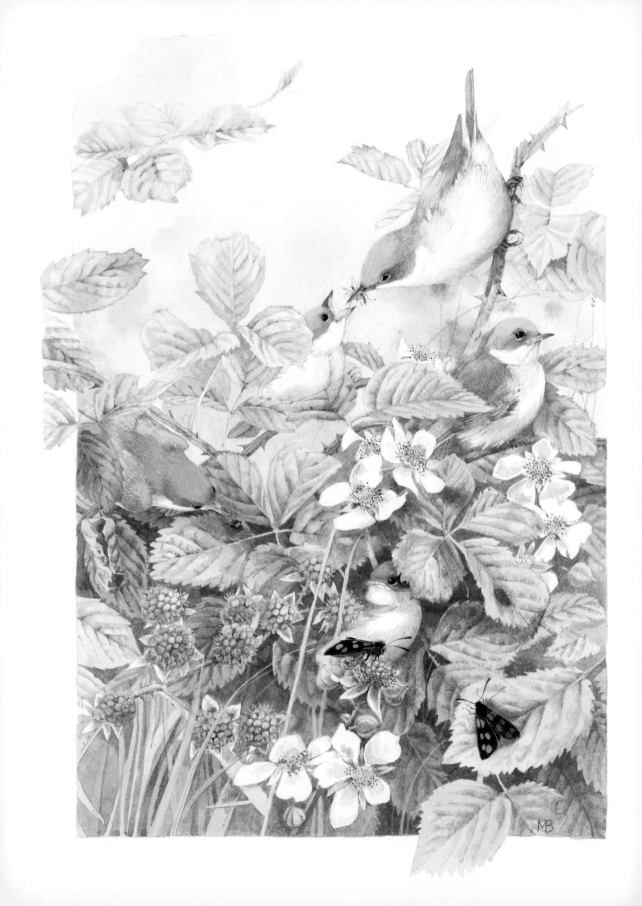

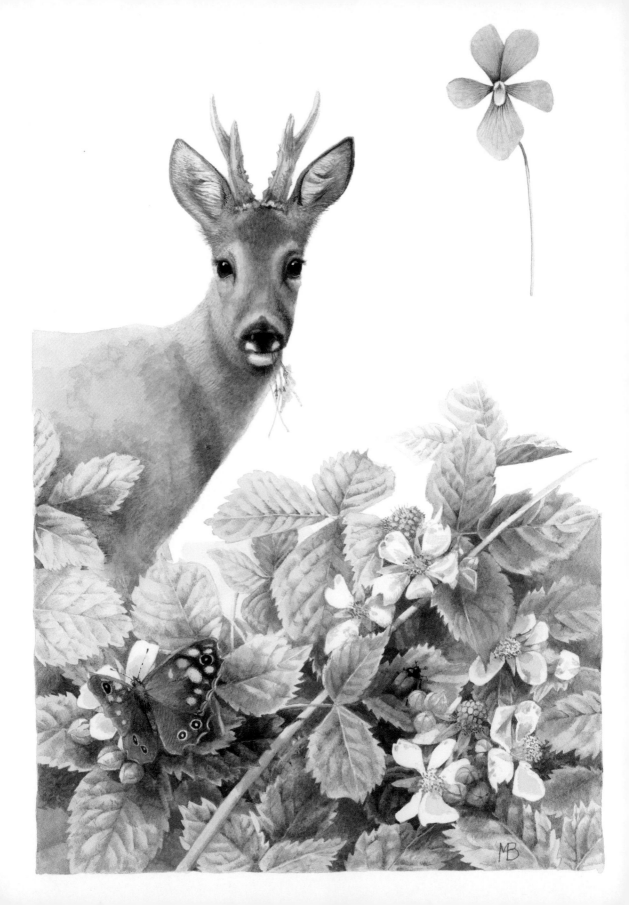

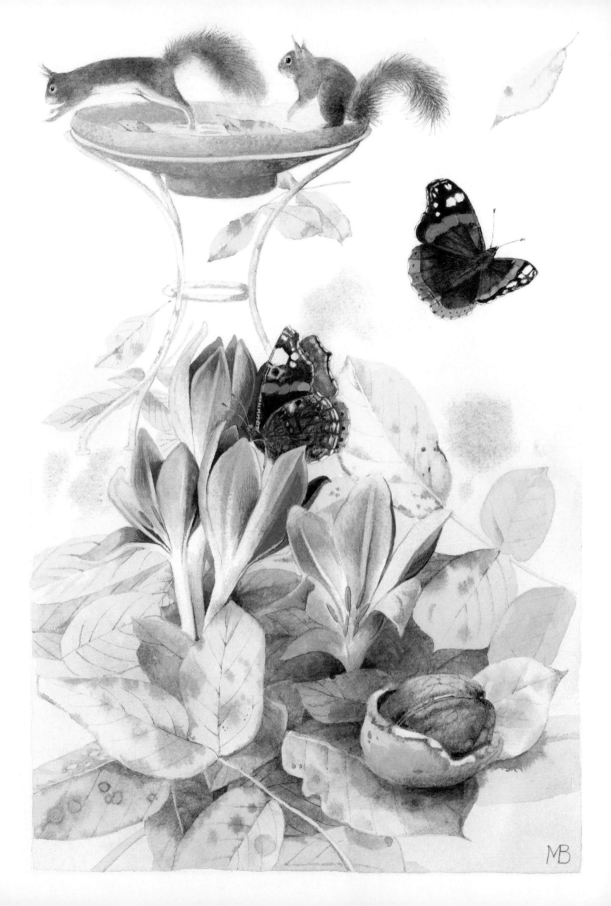

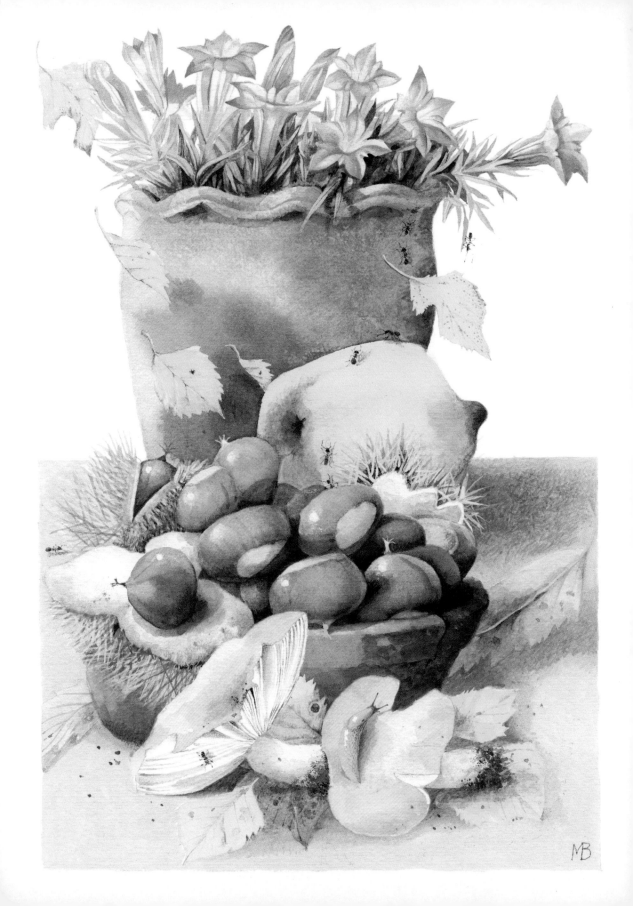

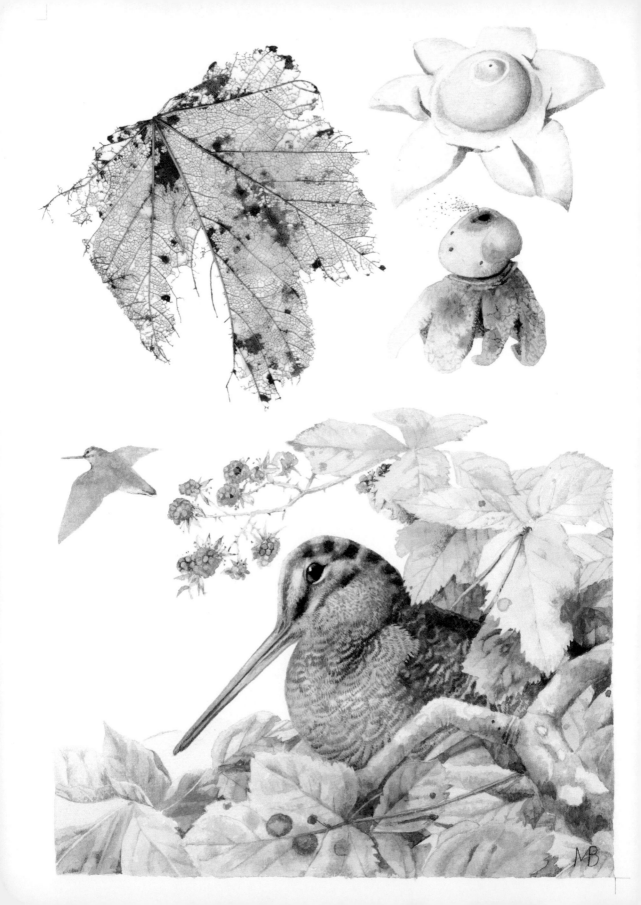

POSH® COLORING BOOK
INSPIRED BY NATURE

copyright © 2017 by Marjolein Bastin. All rights reserved.
Printed in China. No part of this book may be used or reproduced in
any manner whatsoever without written permission except in the case
of reprints in the context of reviews.

Andrews McMeel Publishing
a division of Andrews McMeel Universal
1130 Walnut Street, Kansas City, Missouri 64106

www.andrewsmcmeel.com

20 21 22 23 24 RLP 10 9 8 7 6 5

ISBN: 978-1-4494-8640-2

Editor: Dorothy O'Brien
Designer: Julie Barnes
Production Editor: Katie Gould
Production Manager: Tamara Haus

ATTENTION: SCHOOLS AND BUSINESSES
Andrews McMeel books are available at quantity discounts
with bulk purchase for educational, business, or sales
promotional use. For information, please e-mail the
Andrews McMeel Publishing Special Sales Department:
specialsales@amuniversal.com.